Lithography

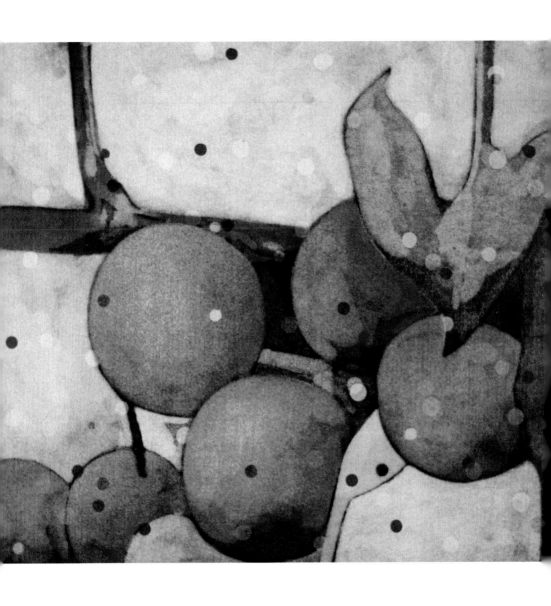

Stone Lithography

PAUL CROFT

WATSON-GUPTILL PUBLICATIONS/NEW YORK

First published in the United States in 2003 by
Watson-Guptill Publications
770 Broadway
New York, NY 10003
www.watson-guptill.com

Cover design by Dorothy Moir
Designed by Janet Jamieson

Library of Congress Control Number: 2002109815

ISBN 0-8230-4924-8

First published in Great Britain 2001 by
A&C Black Publishers
37 Soho Square, London W1D 3QZ
www.acblack.com

Front cover illustration: *Asparagus and Fish*, Paul Croft, UK. 11.6 x 8.8in., 1999.
Back cover illustration: *Girl with a cat*, Clarke Hulton, UK. 5.2 x 10.2in., 1931.
Frontispiece: *Warm Light*, Jeffrey Sipple, USA. 15.2 x 20.4in., 1997.

Publishers note: printmaking can sometimes involve the use of dangerous
substances and sharp tools. Always follow the manufacturer's instructions
and store chemicals and inks (clearly labelled) out of the reach of children.
All information herein is believed to be accurate, however, neither the author
nor the publisher can accept any legal liability or errors or omissions.

Printed in Malaysia by Times Offset (M) Sdn.Bhd.

First Printing, 2003
1 2 3 4 5 6 / 07 06 05 04 03

CONTENTS

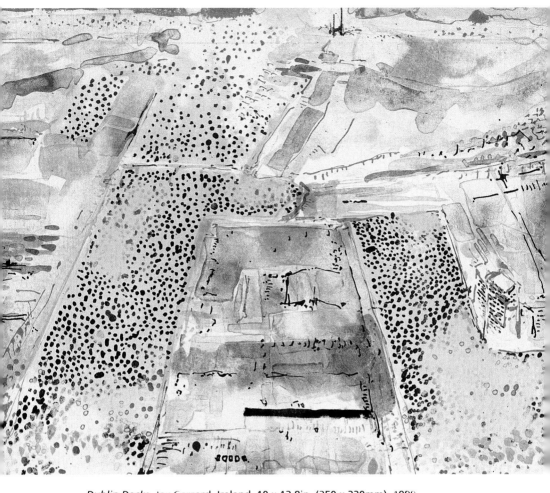

Dublin Docks, Joy Gerrard, Ireland. 10 x 12.8in. (250 x 320mm), 1999
A four-colour lithograph drawn with tusche wash.

ACKNOWLEDGEMENTS

In the course of writing this book I have met and have been in contact with numerous people who have offered me information, help and advice and, of course, images. Inclusion of contemporaneous lithographs, most of which have been made in the last decade, was an important intention from the outset. It has been most interesting and gratifying to see that lithography is so popular and is being used in inventive and imaginative ways to create a wide range of images. Thanks are due to all those artists who have sent me slides of their work, and I have tried to include at least one image from each artist, although within the limited space of this book, this has not always been possible.

I also wish to thank Rosemary Simmons, David Barker and Linda Lambert for all their help and support. Special thanks are also due to David Dubose at Seacourt Print Workshop in Bangor, Northern Ireland who so patiently posed for the studio shots! I would also like to thank Alastair Clark at Edinburgh Printmaker's Workshop, James O'Nolan at the Graphic Studio in Dublin, William Fisher from the Southern Graphics Council in the USA, Hanke Ernst at Steindrûckerie in Switzerland, Cynthia Barber at the Tamarind Institute, Robert Meyrick and Neil Holland at the School of Art in Aberystwyth, all of whom have helped to encourage artists within their own areas to submit work for this project.

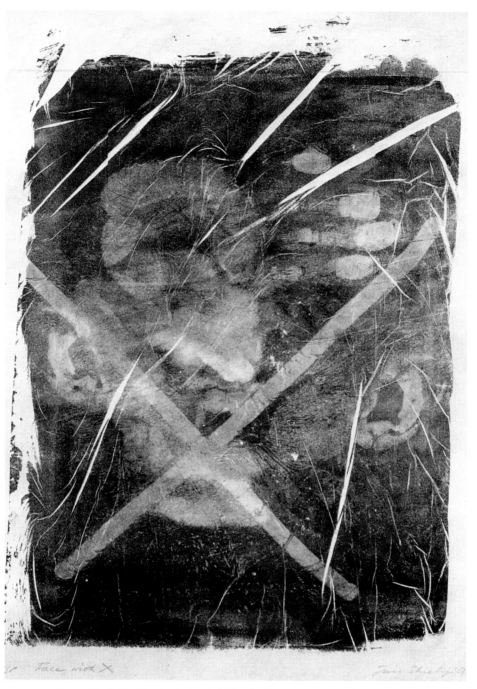

Face with X, Jim Sheehy, Ireland. 15.2 x 11.2in. (380 x 280mm), 1991
In this lithography a transfer was taken onto clingfilm from an inked surface that
had previously been used to take face and hand impressions. The cross was made
by drawing his finger through the ink on the film, before it was transferred on to
the stone.

INTRODUCTION

My first memories of lithography date back to the early 1980s when, as a student at Edinburgh College of Art, I became interested in zinc plate lithography during my final year of degree study. Fascinated by the especially beautiful way that tusche washes reticulate and print, I endeavoured to print a series of black-and-white images, trying mostly in vain to avoid scumming and filling-in occurring. Despite consulting a whole array of books at the time, and gaining often conflicting advice on how best to print, I found that as much as I loved lithography, it really did not appear to love me.

Despite the fact that the premise for lithography is a seemingly simple one – that grease and water cannot readily mix – in practice lithography can be a most complicated process to understand and master. This became particularly apparent when I started teaching lithography at the University of Ulster in Belfast. Although I had at that time gained some experience of the medium and was able to print in a reasonably competent manner, I found it very difficult to teach to students a process that I myself found difficult to understand.

Partly in response to this dilemma, in 1994 I applied for, and was fortunate to be accepted on to, the Printer Training Programme at the Tamarind Institute in Albuquerque, USA. This two-year Master Printer Training Programme is possibly the best course of its kind, covering quite literally all aspects of stone and plate lithography. At the Institute, the then Education Director Jeff Sipple was an excellent teacher who provided us all with information on each of the processes, and then encouraged us to complete our own research. As result I now have a better understanding of lithography and have become proficient in printing.

In many respects this book has come about as a direct result of my training at the Tamarind Institute, and I should very much like to acknowledge the help and instruction that I received there. Originally intended to cover both stone and plate lithography it was found that such a large subject could not be contained in a book of this size. The book is therefore intended as an instruction manual for all those who wish to learn how to make lithographs from stone. It will hopefully be ideal for use in colleges, print workshops and in artists' studios, and will satisfy the questions of college students, artists and those who are merely curious at how such a wonderful process can be used to print images.

As far as possible, explanations and clear instructions are given for as many of the processes of stone lithography that could be included, ranging from simple printing in black and white to more difficult techniques such as acid tint and stone engraving. Although I have tried to be as comprehensive as possible, it cannot be stressed enough that good printing develops as a result of studio experience and sheer hard work. It is also important to develop a well-disciplined approach to lithography, being critically aware of problems and mistakes and solving these in a level-headed manner. Working in a well-organised studio with appropriate machinery, tools and materials will also obviously be of benefit.

Of course it is important to be adventurous, to try out new things, to be ambitious and above all, to enjoy lithography. The methods that I have written about are ones that work well for me. Feel free to use these as a basis for experiment, research and developing your own ways of working that will serve your own interests and needs. Happy and successful printing!

Paul Croft TMP

Chapter 1
ARTISTS
AND PRINTERS
OF LITHOGRAPHY

Even after 200 years of use, and despite major advances in automation, photography and more recent developments in electronic imaging and reproduction, stone lithography still manages to retain its quite magical appeal and is much used by artists today.

Lithography was discovered and developed in Bavaria in 1798 by Alois Senefelder (1771–1834), an unaccomplished playwright who was searching for an effective and inexpensive way of publishing his own writings and musical scores. Purchasing blocks of limestone from the local quarries in Solnhofen, he had originally intended to use these for engraving, as a cheap alternative to plate.

His discovery of the principle of lithography, depending as it does upon the 'mutual repulsion of grease and water', is recorded in one of those legendary, and seemingly unlikely, anecdotes of history. Senefelder, so the story goes, was writing down his mother's laundry list, writing on to a block of limestone using ink composed of wax, soap and lampblack. Curious to see if this mixture would act as an acid resist as in intaglio printing, he etched the stone with diluted nitric acid. While there was no appreciable change in level on the stone he subsequently discovered that providing the stone was kept damp with water, the written areas could be inked with greasy printing ink while the non-image areas would continue to repel it.

In his treatise *Vollständiges Lehrbuch der Steindrückery*, published in Munich in 1818, Senefelder described his discovery as *chemical printing*. Certainly unlike intaglio or relief printing that rely upon a *physical* manipulation of a material such as plate or wood, lithography is a *planographic* process that relies upon *chemical* manipulation of a totally flat surface. Having first drawn the image using greasy crayons and ink, the stone is then processed using gum arabic and nitric acid in a procedure known as 'etching the stone' (not to be confused with the intaglio process). As a result of this, two *diametrically opposed surfaces* are formed on the stone, one grease attractive enabling the image to be inked and printed, the other grease repellent ensuring that non-image areas remain ink-free.

Due partly to the political climate during the Napoleonic wars, and Senefelder's obvious determination to obtain and retain full patent rights for the process, the initial establishment of lithography in Europe was somewhat erratic. In 1799 however, as a result of a commission to publish the work of the composer Franz Gleissner, Senefelder was forced to share his knowledge with the Offenbach brothers, Friedrich and Philipp André.

Soon after, a press was established in London in 1801 by Philipp André and between them they secured a Royal Patent for lithography in England, while Fredric received a similar licence in Paris the following year. As these and other presses were established throughout the cities of Europe, the number of skilled lithography printers increased, and many went on to set up their own businesses. Thus the refinement and dissemination of lithography advanced, so that by 1822 there were no fewer than 18 presses in Paris[1], and many more had been established throughout France and Germany, printing everything from texts to textiles.

Whilst the principle of lithography is deceptively simple, in practice it can be a complicated process, and lithography printers are skilled professionals. Although many painters and sculptors may want to make prints, few often have the time to learn the intricacies of lithography. As a result of this there has always been a strong tradition of collaboration between printers and artists. In all such collaborations the printer acts as a

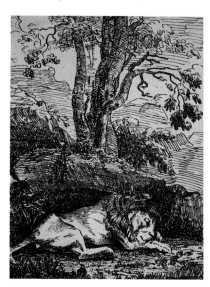

Lion Asleep, P. Bayley, UK.
12 x 9.2in. (300 x 230mm), 1802.
An early example of polyautography. In these first lithographs the image was quite crudely drawn using pen and ink.
Collection of the University of Wales.

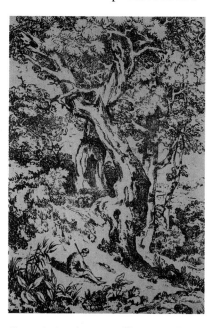

Figure in Landscape, William Havell, UK.
12.4 x 8.8in. (310 x 220mm), 1804.
A slightly later example of polyautography.
Collection of the University of Wales.

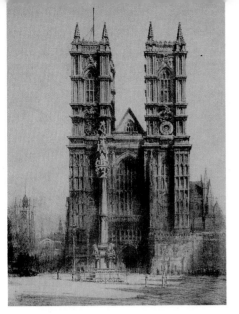

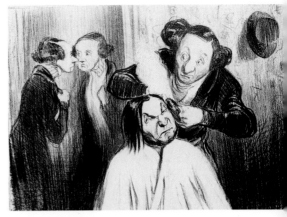

Westminster Abbey, H. G. Hampton, UK, 12.8 x 9.2in. (320 x 230mm).
This 19th-century architectural print is an example of chiaroscuro printing using two stones to first print a tint and a drawing on top.
Collection of the University of Wales.

Un Coup de Feu, Honoré Daumier, France, 7.3 x 9.6in. (182 x 240mm).
A good example of a crayon drawn lithography. Many of Daumier's prints were included in the satirical magazine *La Caricature*.
Collection of the University of Wales.

facilitator and adviser, graining stones, processing images and printing the edition, whilst the artist retains sole responsibility and credit for the final print.

As early as 1801, Philipp André was keen for artists to exploit the process, and working with a group of notable artists, started a portfolio entitled *Specimens of Polyautography*, including work by Benjamin West, the then President of the Royal Academy.

While many of these early prints were crudely drawn using simple line, the images by West were drawn using lithographic crayon and were much more difficult to print. Although not finally printed until after André's departure from London in 1805, these were the first artist's lithographs to have been published anywhere[2]. In spite of this achievement, with the exception of Thomas Barker of Bath who worked with the printer D. J. Redman, collaboration was not well-established in England until the printer Charles Hullmandel set up his press in London in 1819. However, collaboration took on new meaning when the printer Godfrey Engelmann (1788–1839) established a press in Paris in 1816. As a skilled printer he had developed crayon lithography to a high level and encouraged many French artists, including Delacroix and Gericault, to make some of the most sophisticated lithographs at that time.

A massive project entitled *Voyages Pittoresques et Romantiques dans l'ancienne France* was also started by Engelmann in 1820 and was not to be completed until long after his death in 1878. Satisfying the Romantic

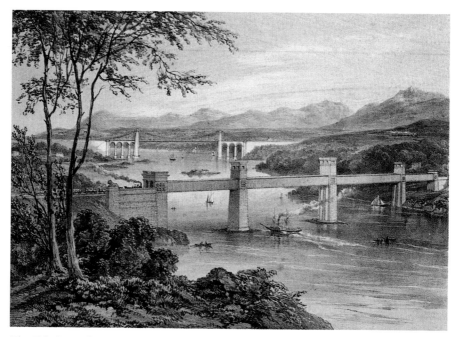

The Tubular and Menai Suspension Bridge, Bangor, Wales. 8 x 11.6in. (200 x 290mm).
A typical example of lithography being used to illustrate a topographical subject
from the middle of the 19th century. Printed in black and white, and hand coloured
using watercolour.
Collection of the University of Wales.

appetite for topographical subjects, many of the images produced for
this vast publication include surveys of landscapes, town scenes and
archaeological sites. Numerous artists became involved, including the
English artists Richard Parkes Bonnington and Thomas Shotter Boys.
Collaborating with the English printer Charles Hullmandel, Boys also
published a similar suite of topographical prints entitled *Picturesque
Architecture*.

Working together, they developed a sophisticated method of
chromolithography that Hullmandel patented as *lithotint*, involving a
technique of drawing on the stone, known as *stumping* and an accurate
form of registration using pins.

Despite a period of flourishing activity that lasted from 1820 until 1835,
much of the vitality seen in many of the early lithographs was lost and the
process came to be associated with reproductive art. The public demand
for colour images led finally to unimaginative mass-produced works,
drawn mainly by *coloristes* who were employed to copy images from other
media. Many of the popular prints printed after 1835 by the American
company of Currier & Ives, and even by the French company of Lemercier,
were considered to be commercial and mediocre.

Photography too, soon supplanted lithography's role in portraiture, also becoming important for the recording of topographical scenes. In one area of publishing, however, lithography remained an important vehicle, being used by Honoré Daumier to produce his witty, satirical and often quite cutting drawings of the French Establishment, printed in the weekly publication *La Caricature*.

From 1878 a renewed interest in the creative use of lithography in England was prompted by James McNeil Whistler, working in his typically unorthodox manner with the printer Thomas Way. Despite heavy criticism at the time, he was encouraged by the potential for working in a more spontaneous manner using transfer techniques, and also experimented with lithotint, working directly on the stone.

The revival of lithography was, however, centred in Paris, leading to the 'golden age of lithography', beginning in about 1889 and continuing into the first decade of the new century. A number of printers who had worked for Lemercier, including Auguste Clot, Edward Ancourt and Jules Chéret (Chéret worked with Toulouse Lautrec to revolutionise poster design in Paris), opened their own workshops and began collaborating with artists, writers and entrepreneurial publishers such as Ambroise Vollard and Gustav Pellet.

Influence from Japan, and colour theories devised by the Neo-Impressionists and Pointillists George Seurat and Paul Signac, stimulated the production of some of the best colour lithographs, and certainly aided the evolution of colour lithography at that time. The custom of producing portfolios or albums of prints was initiated by Vollard and Pellet and many of the better known collections include *Quelques Aspects de la Vie de Paris*, illustrated by Bonnard in 1895, and *Paysages et Interieurs*, drawn by Vuillard in 1899.

The direction taken by lithography in Europe throughout the first half of the 20th century was characterised by further periods of decline and revival, and was certainly affected by the two World Wars. In spite of this, during the interwar period, artists such as Utrillo, Vlaminck and Matisse began making prints with Fernand Mourlot, whose workshop was based in Paris. Immediately following the Second World War, Picasso produced his famous series of *Bulls*, also printed by Mourlot; editioned in eleven different states, and showing a metamorphosis from representation to pure abstraction[3].

Certainly artists from every conceivable movement have made some contribution to lithography. At the 1913 Armory Show in New York, prints by Gauguin, Munch, Redon and Vuillard were exhibited along with work by the Fauves, Cubists and Expressionists. In the late 1930s and during the Second World War, numerous artists representing Surrealism and Abstractionism moved to New York and began influencing a younger generation of artists there.

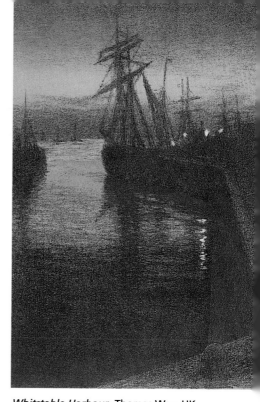

The Smith's Yard, James McNeil Whistler, USA. 15 x 10.3in. (375 x 258mm), 1895. Although much criticised at the time, Whistler made good use of transfer lithography.
Collection of the University of Wales.

Whitstable Harbour, Thomas Way, UK. 14.4 x 10.8in. (360 x 270mm), 1911. Lithograph by Way who printed for Whistler.
Collection of the University of Wales.

In the USA, although the first press had been established in Philadelphia in 1819, lithography had developed there as a commercial enterprise, and few artists of the 19th century had explored the medium.

The first few decades of the 20th century were dominated by a number of successful printers including George Miller, Bolton Brown and Grant Arnold. Miller's workshop, set up in New York in 1917, was the first 'atelier' of its kind in the USA and he began printing for Albert Sterner, Joseph Pennell, Arthur Davies and George Bellows.

Having learnt lithography in London, Bolton Brown set up his studio at Woodstock in 1918. A close relationship soon developed between Brown and George Bellows, who found him easier than George Miller to work with. Brown also printed for Sterner, John Sloan and Rockwell Kent.

In 1928 Grant Arnold first learnt lithography at the Student's League in New York, becoming senior printer there until 1931 when he printed for Thomas Hart Benton and Don Freeman. In the 1930s, Arnold moved to Woodstock and eventually took over the press set up by Brown when he died in 1936.

The Great Depression and the following years of war were especially difficult for artists and printers alike. Support however did come from The

Federal Arts Project which from 1935 helped print workshops throughout the country by securing equipment and printers to work for public sponsored projects. Of the many FAP workshops established, the New York studio was particularly successful, printing over 130 lithographs by artists including Stuart Davis, Harry Gottlieb and Margaret Lowengrund[4].

With the USA's entry into the Second World War, however, the Federal Arts Project was cancelled and the profile of lithography and printmaking in general declined once again.

Despite having made a number of lithographs with Ted Wahl in the late 1930s, Jackson Pollock and other Abstract Expressionists rejected the graphic arts in favour of paint, and as a consequence activity in printmaking was confined to selective art schools across the country.

During the 1950s the dire circumstances of printmaking in the USA had become particularly acute. As a result of the slump in printmaking many printers had gone out of business, still more had died and many others were taking on less and less business from artists. With the exception of Lynton Kistler, who was still printing for artists in Los Angeles, by the late 1950s those American artists who wanted to make lithographs either had to travel to Europe to work with printers there, or had to make do trying to teach themselves how to print at home.

For one artist, June Wayne, this situation was clearly quite unacceptable and, during a couple of visits to Europe, she began to formulate a daring project to set up a workshop that would serve the interests of American artists. Having discussed her ideas with Clinton Adams she approached the Ford Foundation for funding and, in 1959, received a three-year grant of $165,000 to set up the workshop in Los Angeles.

Opening on Tamarind Avenue in 1960, the Tamarind Workshop was seen by the Ford Foundation as a West Coast counterbalance to East Coast studios that had already been established, notably ULAE (Universal Limited Art Editions) set up by Tatyana Grosman (1904–1982) in 1957, and the Pratt Graphic Art Centre also set up in 1957. In comparison with these other studios, the importance of Tamarind was clear from the outset, evident from its constitution and aims, and its recognition by the Ford Foundation which had only given $21,000 to the Pratt Centre but later provided Tamarind with an additional three instalments totalling over $2million between 1962 and 1970.

The aims of the Tamarind Workshop were basically quite straightforward: to train a body of Master Printers who would continue to work with artists and set up their own studios across the USA; to encourage collaboration between artists and printers, and to instigate a programme of publishing artists' prints; and, finally, to promote lithography and develop the market for prints in the USA as a whole.

In every respect the Tamarind Institute has been supremely successful. During the last 40 years of its existence, numerous Master Printers have

graduated and set up studios across the USA and elsewhere. Of the many workshops in the USA today, perhaps the best known are Gemini and Tyler Graphics, both established by Kenneth Tyler, the previous Technical Director at Tamarind. Other notable studios include Landfall Press in Chicago, established by Jack Lemon, responsible for publishing the work of Philip Pearlstein, Chuck Close and Jim Dine amongst many others. In 1975 Solo Press was established by Judith Solodkin, the first woman to complete the Tamarind's Master Printer Programme. In recent years she has worked with artists Dotty Attie, Nancy Spero and Howard Hodgkin.

Working with artists and publishing their work naturally has been a major preoccupation at Tamarind, both in Los Angeles and today in Albuquerque. By 1962, some 439 editions had already been printed by the workshop, and the list of artists published before the move to Albuquerque is long and impressive. Artists have included Josef Albers, S. W. Hayter, David Hockney, Françoise Gilot, Sam Francis, Phillip Guston and Edward Ruscha, to name but a few.

It is true to say that Tamarind's impact upon all areas of printmaking has been impressive both in the USA and worldwide. As well as raising the status of lithography and helping to induce the market for prints, the institution has been responsible for research into printing inks, papers and presses, as well as documenting the development of lithography itself.

In the course of writing this book it has been truly gratifying to find that lithography is very much alive and kicking, and is being used to print such a wide range of images. In the UK, Ireland, Canada and the USA, there has been a renaissance in the development of print workshops catering for lithography and other print media. Whilst this book deals primarily with techniques of stone lithography, it has been interesting to learn of exciting new research into waterless lithography, printing from plates, and the development of water-based inks and materials. Many of these issues will be looked at in a subsequent publication.

In the meantime, it is hoped that the information included here will excite a new generation of artists, and that they will want to explore the potential of lithography, using stone, inks and presses.

1 Clinton Adams, *Nineteenth Century Lithography in Europe*, University of New Mexico Art Museum, 1998.

2 Michael Twyman, *Lithography 1800–1850*, Oxford University Press, 1970.

3 Fernand Mourlot, 'The Artist and the Printer' from *Lithography: 200 years of Art, History and Technique*, Well Fleet Press, New Jersey, 1983.

4 Clinton Adams, *American Lithographers 1900–1960*, University of New Mexico Press, 1983.

Chapter 2
PREPARING STONES FOR LITHOGRAPHY

 The nature of lithographic stone

The limestone first used by Alois Senefelder and by the majority of lithography printers since, has been cut mostly from quarries close to the town of Solnhofen in Bavaria. These limestones were deposited in the region towards the end of the Jurassic Period some 155 million years ago, when this region was covered by a warm shallow sea populated by corals and sponges. Layers of silt and mud were deposited in lagoons between coral reefs, resulting in the formation of a particularly fine-grained limestone responsible for the fine preservation of rarely found sponges, fishes and animals. The famous fossil specimens of the *Archaeopteryx lithographica* first discovered in the region in 1861, for example, have provided evidence of the earliest feathered creatures known, and form a possible link in the evolution between reptiles and birds[1].

At least since the Stone Age, Solnhofen limestone has been quarried extensively as a building material, and was used by the Romans for paving the roads of their Empire. It is the extremely fine-grained characteristic of the stone that makes it so useful for lithographic printing, and which resulted in the huge expansion of the stone-cutting industry during the 19th century.

The principle of lithography, relying as it does upon the 'mutual repulsion of grease and water', requires a suitably porous surface that will easily absorb both water and grease. This quality is found in Solnhofen limestone, which is 96% calcium carbonate and fine enough to receive and print drawn images.

Although the majority of the stones used for lithography do come from the same region, they can vary considerably in quality, hardness and in size. Many of the stones will contain fossils, mineral veins known as *infusion lines*, crystals such as iron pyrites, cracks and flaws that will cause each stone to be unique. Such variations inevitably affect the capability and performance of individual stones to print. For the lithographer, therefore, it is important to become acquainted with the stones, and to gain experience of printing from them.

The colour of the stone is dependent upon mineral content, density and hardness, and this will indicate how well the stone may print certain types

of images. Stones range in colour from white, yellow through light grey, dark grey and blue. White stones are the least desirable since they tend to yield coarse images and are generally unreliable for printing. Despite their high-density, dark grey and blue stones are often too dark for most drawing purposes but may be excellent for engraving. Yellow stones, perhaps the most common variety, and easiest to obtain, tend to be softer. Being less dense they allow for a greater penetration of grease and are particularly suited to crayon drawing. Some yellow stones, however, will allow for a greater *reticulation* of washes, although there may be a tendency for these to fill in more readily during printing. Light grey and medium grey stones meanwhile are much denser and harder. Suitable for all types of lithographic drawing, they are able to withstand 'hotter' or stronger etches and thus provide a much more stable element for printing. Being highly favoured, these stones tend to be sought after and are today quite rare[2].

Despite the near exhaustive mining of stone at Solnhofen, it is still possible to obtain new lithography stones from there, and from suppliers elsewhere around the world. Good quality new stones are however expensive and not always easy to source, and some artists have experimented with marble as an alternative. Whilst results can be surprisingly good, marble requires substantial graining and will need much hotter etches than conventional stone.

Secondhand stones are more easily obtained, although even these are becoming increasingly scarce. Used stones will commonly retain images from their final printing and these may well include wine labels, maps and even the occasional fine art print! When purchasing used stones, always check their quality, colour and size, and in particular their thickness and level. Stones that are less than 2in. (5cm) thick will certainly break during printing, and stones that are wedged will be a nightmare to use!

Selecting and graining stones for printing

Selection of a suitable stone and its initial preparation are important concerns. Most well-equipped print workshops will generally hold a selection of stones of varying size and quality, from which a stone appropriate for the image can be chosen.

For printing, the stone should ideally be large enough to accommodate not only the image but also the size of the printing paper that is going to be used. This is necessary since registration marks used to position the paper correctly during printing will normally be made on the stone as well.

Ensure that the stone is of sufficient quality, that there are no obvious cracks or flaws and that it is not too thin for printing. Stones containing numerous fossils with a heavily speckled appearance should be avoided if

'flats' of colour are to be printed, although crayon and wash will probably print fine. Infusion lines incorrectly thought to be cracks running through the stone may sometimes print as either a white line or as a dark line or not at all. Such lines can normally be avoided through careful planning of an image, although it should perhaps be recognised that these lines are an inherent characteristic of stone lithography and will add a note of authenticity to the final image.

The purpose of stone graining

Unless the stone has already been prepared, the previous image remaining on the stone must first be removed through the process of graining. This involves the use of abrasive carborundum grits essentially to clean and polish the stone, and provides a grease-sensitive surface for the new drawing. During graining a fractional layer is removed from the top of the stone and this strips away any remnants of ink and greasy *oleomanganate of lime* that will have penetrated the stone from the previous printing. The graining process will also remove any traces of gum arabic, which acts as a desensitising agent and which would prevent any subsequent greasy drawing from taking hold on the stone.

The graining process is also employed to ensure that a completely level surface is achieved. Being a *planographic* process, lithography obviously requires a totally flat and level surface for the image to print perfectly. A stone that is not level, containing areas of unequal height – 'hollows' and 'rises' – will print poor impressions and, in some cases, may cause the stone to fracture during printing.

Graining can also be used to some extent to correct a *wedged* stone, which may be even only fractionally thicker at one end than at the other. Badly wedged stones, however, will be impossible to print and may require planing by a professional stonemason.

Carborundum grits used in graining

Graining always takes place over a specially constructed graining sink, with a duckboard platform to hold the stone in position and a trough below to collect residue stone particles and any unused grit that would cause the drainage to become blocked. Grit lubricated with water is then used with either a *levigator* or a smaller 'graining stone', to cause the abrasion of the upper surface of the stone. Grit is easily obtained from most printmaking suppliers in a range of grades from coarse through to fine. Normally coarse grit is used for initial graining purposes, although I know of one artist who makes use of sand from a nearby beach. Finer grades are then used to progressively polish the stone to a fine smooth surface. While the specific grades of grit used in workshops may well vary, it is normal practice to employ at least three or four grades as follows:

Grade #80 Coarse grade grit used for image removal
 and levelling.
Grade #100 Medium grade grit for removing ghost
 images on the stone.
Grade #180 Medium grade grit for polishing the stone.
Grade #220 Fine grade grit for fine polishing of the
 stone surface.

It is possible of course to obtain even finer grades such as #320 and #400, which are sometimes used to obtain a highly polished surface for stone engraving. Whichever grits are used, it is most important that the different grades are stored in separate jars or tins near the graining sink; they should never be mixed together.

Initial graining using a levigator and coarse carborundum grit #80

The initial objectives for graining are to remove from the stone the existing inked image made by the previous artist, and to then obtain a reasonably level surface, which can subsequently be polished using finer grades. The most effective way to achieve this is to employ coarse grit such as grade #80 and use a levigator to proceed to grain the stone in the following manner:

1. Having first positioned the stone on the graining sink, as much of the inked image as possible should be washed out using white spirit or lithotine, and a clean rag. Ink that has remained upon the stone for some time may prove difficult to remove and may well not wash out at all.

2. Rinse the stone well with water to remove debris created by the washing out and to remove any gum arabic lying on the stone surface.

3. Ensuring that there is no debris on the surface, flood the stone with a film of clean water. Then apply an even layer of #80 grit to the surface of the stone so that a majority of the surface is covered. Too much grit applied will simply be wasted during graining, while too little will normally result in severe and unwanted scratching. The levigator should be well rinsed of any grit and any other incidental material.

4. Placing the levigator at one corner on top of the stone, the levigator should then be set into a spinning motion by turning the handle in a clockwise manner (counter-clockwise if this is more convenient). This will be quite awkward for the uninitiated, but will become easier with some practice.

5. At the same time as spinning the levigator, it is also necessary to move it across the whole surface of the stone, so that

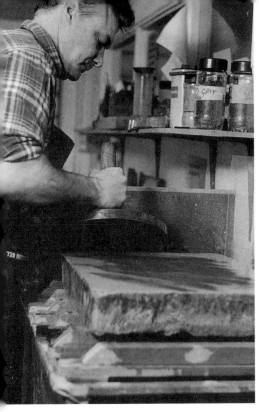

(a) Once carborundum has been applied, the levigator is then lifted on to the stone.

(b) Graining with the levigator.

(c) Using a small stone to grain.

(d) Graining with a smaller stone.

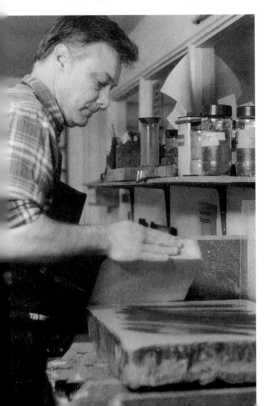

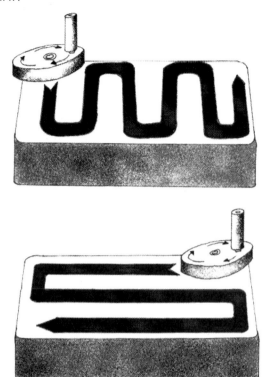

Figure of eight graining pattern.

theoretically the surface will be grained uniformly. At this stage it is useful to adopt a *basic figure of eight graining pattern* as this will most rapidly remove any remaining traces of ink left on the stone.

6. Graining in this manner should be continued until a single pass has been completed on the stone, when the grit will have become exhausted and a cement-like substance will have formed on the surface, making it difficult to turn the levigator any further.

7. Upon the completion of a single pass, the levigator should be removed carefully from the stone and then both stone and levigator should be rinsed well with water to remove all traces of debris and grit.

8. Generally, I like to complete at least two or three passes at this stage, using coarse grit, since this will certainly remove all traces of the inked image and will provide a reasonably clean surface for checking the level of the stone. Once the inked image has all but disappeared, rinse the stone well and then fan it dry.

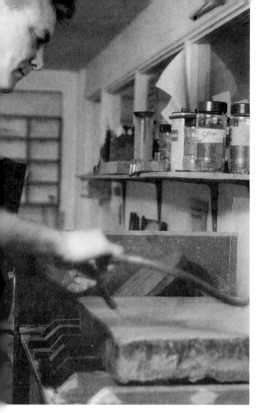

(e) Rinsing the stone with water.

(f) Fanning the stone dry.

(g) Checking the level.

(h) Filing the edges of the stone.

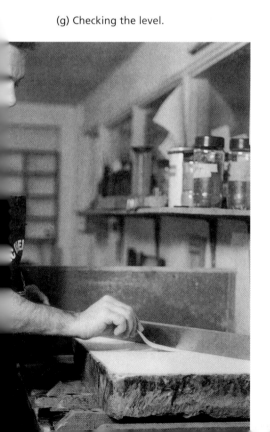

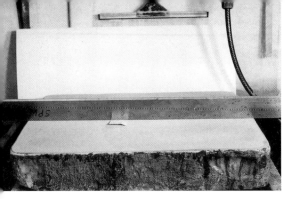

Checking the level across the length of the stone.

Checking the level across the width of the stone.

Checking the level across the diagonal.

Checking the level of the stone

The *level* of the stone is the term used to describe the uniformity of flatness across the whole of its surface, and obviously it is important that the level of the stone is kept as uniform as possible. Unfortunately, careless graining in itself can help to accentuate already existing irregularities or can cause new ones to appear. Consequently, it is advisable to check the level on the stone on a regular basis since both hollows and rises can adversely affect the printing of the image. Hollows may well cause lightness and lack of definition while conversely rises will cause darkening and *filling in*.

Checking the level of the stone should always be carried out with the surface completely dry and free of grit. Use a clean soft paintbrush to remove any particles of grit lying on the surface. The level of the stone is easily checked using a true metal straight edge.

This is placed across the stone at periodical intervals with a small piece of cut filter paper placed between it and the stone. Wherever it is possible to remove the filter paper from beneath the weight of the steel ruler will suggest that a hollow exists at that point. The straight edge should be used in this manner to check the level across the length and width, and along the diagonals of the stone.

It is common for hollows to develop within the middle area of the stone, since there is generally an unconscious reluctance to grain the edges of the stone sufficiently, particularly for the beginner. To rectify this, it will be necessary to grain only the edges of the stone avoiding the middle area for a number of passes until the stone becomes level again. Conversely, rises will need additional graining. In some cases, the middle of the stone may seem high and this will require graining that avoids the edges.

The stone should also be checked at this stage for problems concerning wedge. This is achieved by measuring the thickness of the stone at intervals around the edges, using a pair of calibrated callipers. Differences in stone thickness of about ⅛in. (2–3mm) can normally be corrected through persistent and selective graining. Major problems however will require the stone to be planed professionally by a stonemason or commercial stonecutter.

Continued graining of the stone

Once the level has been checked, subsequent graining should obviously take account of any discrepancies, avoiding low areas and concentrating upon the high areas. If, however, the stone appears to be level then figure of eight graining can continue as normal.

Whilst the inked image will have largely disappeared after about two or three passes, a *ghost image* will remain for some time, most noticeable when the stone is dry. This ghost image is the result of grease in the form of oleomanganate of lime, penetrating the surface of the stone, and represents a sub-surface copy of the previously drawn image. Since this soap-like substance is *oleophilic* or 'grease loving' it will continue to attract grease and ink if it is not totally removed. In other words, the ghost image needs to be removed from the stone otherwise there is a danger that it too will ink up when the next image is printed.

Normally an additional three or four passes using coarse grit will be sufficient to remove this, although an image that has remained on the stone for some months or years will need to be grained for longer, since oleomanganate of lime will have penetrated deeper into the structure of the stone. Some stones do tend to retain ghost images more than others. Using a dilute solution of acetic acid (diluted 1 part acid to 9 parts water) during graining can help to eliminate ghost images more quickly. Instead of flooding the stone with water, simply pour the solution over the stone, apply grit and grain as normal.

After completing an additional three or four passes using coarse grit, rinse the stone again, dry it and check the level. If the stone appears to be level and if most of the ghost image has disappeared, then graining should proceed using finer grades of grit to help polish the surface for the drawing. Four passes of grades #100, #180 and maybe six short passes of #220 should be sufficient to complete this process.

Scratching, sometimes only visible when the stone is dry, readily occurs when traces of coarse grit contaminate finer grits during graining. Should scratches occur on the stone, these will show as white lines when the image is finally printed. To remove scratches from the stone it may be necessary to grain for a couple of passes using the previous grade of grit. Thus if scratches appear while graining with #180, grade #100 will need to be used to remove them.

To avoid this, never mix grades of carborundum together. Similarly, when changing from one grade to another, it is essential that the stone, levigator and the sink area are thoroughly rinsed with water to remove all traces of coarser grit. It is also a good idea to check the bottom edge of the levigator, which can become sharp through constant use. Use a fine metal file to round off any sharp edges.

When using #220 grit, it is advisable to use a small polishing stone instead of a levigator. A broken piece of stone small enough to fit in the palm of your hand is ideal. Ensure that the side making contact with the stone is flat and the edges are filed well to remove any protrusions. Use copious amounts of water and grain slowly for a shorter period of time, even if this means washing away quantities of unused grit.

Once graining with #220 has been completed, rinse the stone well and then dry it with a hair dryer. Check the stone for scratches and for level. Finally it is a good idea to file the edges of the stone using first of all a coarse and then a fine metal file. The better and more rounded the edges of the stone are, the cleaner they will remain during printing. The edges can also be further polished to a finish using a *Tam O'Shanter Snake Slip Stone*.

Rinse the stone one final time and dry it with a hair dryer. The stone is now ready for drawing. However if it is not to be used immediately it should be well covered with a clean sheet of acid free paper and stored in a safe place.

1 K.W. Barthel, N. H. M. Swinburne and S. Conway Morris, *Solnhofen: A Study in Mesozoic Palaeontology*, Cambridge University Press, 1994.

2 Garo Antreasian and Clinton Adams, *The Tamarind Book of Lithography*, Abrams, 1970.

Chapter 3

PREPARING FOR AND DRAWING ON THE STONE

 Approaches to drawing on the stone

As with other forms of printmaking, there are probably as many different approaches to drawing lithographic images as there are artists using the medium. All artists will of course have their own aspirations and will respond to the medium uniquely in order to develop their own personal styles and methods of working. For many, there is the excitement of drawing onto the surface of freshly grained stone, whilst for others this notion can be an inhibiting factor – they will prefer to draw upon more expendable plates. Some artists may simply enjoy the freedom of working with drawing materials that produce a range of mark-making not easily achieved in any other medium. Others will see lithography as an opportunity to expand and develop visual ideas in new and exciting directions, whilst still others may prefer to exploit the reproductive aspect of printmaking to develop multiples of an already existing image.

Images are drawn onto freshly grained stones using a wide range of greasy crayons and liquid drawing inks composed of grease and beeswax, and the lampblack that provides colour enabling the drawing to be seen clearly upon the surface of the stone.

Lithographic crayons, or *chalks* as they are sometimes called, can be used to develop pastel-like images consisting of a broad range of tone and a variety of line and mark. Crayons are probably the easiest of materials to use on the stone and have been the preferred choice for many artists working in the tradition of 'crayon-stone', as advocated by the American printer Bolton Brown working in the 1920s[1]. Softer and more atmospheric charcoal-like drawings can also be developed from smudging and smearing *rubbing-crayon* on to the stone.

Liquid drawing inks known as *tusche* can be applied with either a brush, to create painterly effects, or with a nib pen to provide pen-and-ink line drawings. Normally tusche is mixed with distilled water, but it can also be dissolved with a number of different solvents to achieve a diversity of printed mark. Many artists, such as Scottish artist Elspeth Lamb, are

interested in how tusche washes dry to a unique reticulated pattern on the stone, and often plan their images to exploit these qualities.

An alternative approach to working on stone is suggested by methods of erasing using *hones*, Tam O'Shanter Snake Slip Stones, pumice, knives and blades, and burning with nitric acid etches. In the manner of mezzotint, images can be developed in negative – seen as white against a black field – in the processes of *manière noire* and *acid tint*. Both of these techniques are more fully described in Chapter Eight, whilst other techniques involving photocopy transfers and similar methods are further considered in other chapters.

As most drawing materials used in lithography are either black or brown, images need to be conceived and developed *tonally* in black on the surface of the stone. Only once the image has been chemically processed during *etching* can the image then be inked and printed in whatever colour desired.

Images drawn on stone thus need to take account of the intensity of the colour that is to be finally used. Sometimes it can be difficult for artists to appreciate that an image that is to print in a light colour, such as yellow

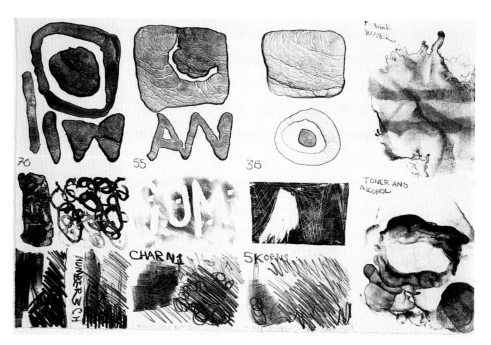

Print from a test stone showing a variety of different drawing materials, including (from top left to right) dark tusche, medium tusche, light tusche, toner and water, Encre zincographique, rubbing crayon applied over gum, scratching into asphaltum, toner and alcohol, Charbonnel No. 3 medium crayon, Charbonnel No. 1 hard crayon, and Korns No. 5 copal hard crayon, Charbonnel No. 5 soft greasy crayon.

will need to be drawn on the stone just as heavily as if it were to print in blue. Commonly such images are mistakenly drawn on the stone much too lightly, reflecting perhaps the artist's desired intention in his or her mind's eye, and then for the printed image to hardly register at all in the colour used. Conceiving of colour images in this way can prove to be awkward for some artists and consequently it would normally be recommended that colour printing is not attempted until a good working understanding of the whole process of drawing and printing has been sufficiently developed from printing in just black and white.

Experience of black and white will also help in the subsequent planning of colour prints. Not unlike the Japanese tradition of colour woodcut, a black-and-white lithograph can be used as a *key image* from which further elements, stones or plates can be drawn to print colour. It is quite common therefore to draw the key image first on stone, and then to draw further colour separations on other elements, printing them in succession, before printing the key last, to 'tie the image together'. An excellent example of a print produced in this manner is the image *Nuestra Senora del Rosario* by the New Mexican artist Victor Goler, and printed by the author using four aluminum plates and a final crayon drawing from stone.

Planning for drawing images

Regardless of aspiration and experience, success in lithography and achieving satisfying results is largely dependent upon good preparation and careful planning at all stages of drawing and printing. Unless a wholly spontaneous approach is being contemplated, a number of issues concerning the size of the image, the size of the printing paper and how the image will be registered on the stone and on the paper, need to be addressed before drawing commences.

In normal circumstances, the stone being used should be capable of accommodating both the size of the image and the printing paper, with a comfortable margin of about 1in. (2.5cm) in all directions. This is necessary for two reasons. Firstly, registration marks that allow for the correct positioning of the paper are normally placed upon the stone and these need to be seen clearly outside of the image and paper areas. Secondly, a sufficient border is required on the stone to permit the *scraper bar* on the press to be safely engaged during printing allowing for start and stopping positions on the stone itself.

The printed image can be planned with borders or alternatively may be seen as 'running off the edge of the paper', as in a *bleed print*. In the former, the size of the image will be smaller than that of the paper, whilst in the latter the image will normally print on to paper that is cut slightly smaller than it.

Whichever format is preferred, both image and paper areas should be established upon the stone by tracing these, and the salient details of the image, in reverse onto the stone, using some prepared *red oxide paper*. Red oxide, a red earth colour that is supplied in powder form and conté crayon, is devoid of grease and can be used on the stone without fear of printing, to trace or sketch out images prior to drawing with lithographic materials.

To prepare red oxide paper, simply dust one side of a sheet of newsprint with the powder and use it like carbon paper. Using conté crayon to sketch out details directly on the stone is a useful approach but should not be applied too heavily, since the chalk will interrupt the subsequent application of greasy crayons and tusche. Remember that unless an offset press is being used, images need to be drawn in reverse to print the right way around.

Registration marks are commonly added to the stone at this stage, although some printers prefer to apply these later during printing. A number of methods of registration can be used such as *crosses*, *pins* and a *tab method* of registration, using punch holes and metal pins. The easiest and most effective method however is *T-bar* registration. In this form of registration, marks that are made on the stone are used to match up with corresponding marks that are drawn in pencil on the reverse side of every sheet of paper used.

Two registration marks are first traced and then cut on to the stone using a sharp blade, at the mid-points along the top and bottom edges of the paper area already traced. A T-mark is normally used to denote the position of the top edge of the paper, with the horizontal bar of the T indicating where the paper edge is aligned, and the vertical corresponding with the midpoint on the paper. A bar-mark meanwhile is added along the lower edge of the paper area at the mid-point, to indicate the positioning of the paper at this point.

During printing, the top or leading edge of the paper is first positioned against the T-mark and then the lower edge is dropped down in to position to match the bar mark. When cutting these marks on to the stone, always use a sharp blade to create a precise line, and ensure that the marks are not cut too deeply otherwise prolonged graining will be required in the future. Setting the corresponding marks on the printing paper is described in the chapter on printing.

The importance of grease in lithographic drawing materials

Since the principle of lithography is so dependent upon the establishment of a greasy image, it is not surprising that the drawing materials used in lithography contain copious amounts of the substance. Throughout the history of lithography, many artists and printers since Senefelder have made their own crayons and inks using proportionate mixtures of grease,

tallow, shellac, varnishes and lampblack. Some artists have drawn success-fully using soap, and an interesting technique of 'soap wash drawing' is included later in Chapter Nine. I can also remember one student pro-ducing a reasonably good image from placing a bag of French fries on top of his stone! However, lithographic crayons, pencils, rubbing crayons, liquid drawing inks and tusche are all produced commercially by a number of companies worldwide. Whilst the constituents of these are very similar, variations in the actual grease content can occur between brands, affecting the way that individual materials perform during drawing.

The proportionate grease content of lithographic drawing materials is an important consideration, since this not only affects the appearance of the drawn mark but will also play an important role in its subsequent etching and printing. As a rule, lithographic crayons and pencils containing larger quantities of grease are capable of producing softer and generally stronger printed marks than those containing lesser amounts. As a result, crayons and pencils are produced in a range from hard to soft, with hard crayons containing very little grease and soft crayons containing much more.

Developing an awareness of how much grease is applied to the stone during drawing is important for the subsequent etching of the stone. Etching uses *gum etches* of gum arabic and nitric acid and, in simple terms, enables the drawing materials to be removed and to be replaced with printing ink, thus facilitating printing. It will be seen that the application of gum etches is largely dependent upon how much grease is present in the drawn image, and that success in etching develops from skill and experience of how each of the drawing materials reacts to the etches on the stone.

Drawing a test stone

For the lithography student, developing a familiarity of working with crayons and tusches can easily be gained through the completion of a *test stone*, whereby a selection of drawing materials are applied in a variety of different ways, and are subsequently etched and then printed. Even for the more experienced it is generally advisable to keep the drawing of an image as simple as possible by limiting the number of different drawing materials used on a single stone to a maximum of about two or three.

To start a test stone, the image area already established on the stone using red oxide paper should be further subdivided into nine and each section drawn up using some of the following media.

Lithographic crayons and pencils

Three major companies worldwide, including the American firms Korns and Stones, and the French company Charbonnel produce most of the crayons and lithographic pencils commonly used in fine art lithography

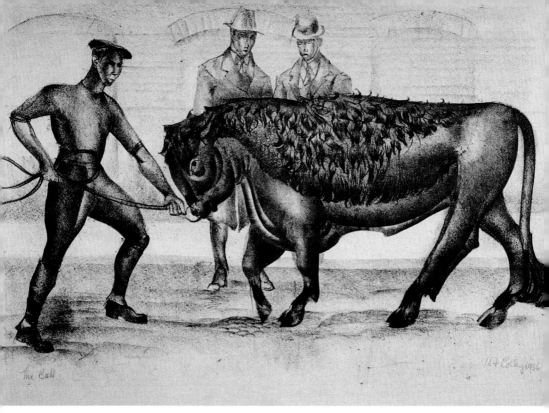

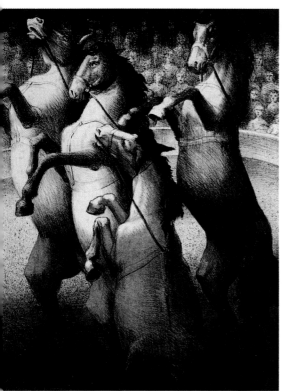

Above:
The Bull, W. F. Colley, UK.
10.6 x 15.8in. (265 x 395mm), 1936.
Lithograph drawn using crayon.
Collection of the University of Wales.

Left:
Circus Horses, F. H. Spear, UK.
14.8 x 11.9in. (370 x 298mm), 1933.
Lithograph drawn using crayon and
splattered tusche, and printed with
a tint stone.
Collection of the University of Wales.

today. They are produced in ranges graded from very soft and greasy to very hard and dry. Confusingly, however, the American system of grading hardness runs contrary to that of the French, resulting in a Korns crayon No. 5, a hard dry crayon with very little grease, being the equivalent to a Charbonnel crayon No. 1, whilst the corresponding Korns crayon No. 1, a soft greasy crayon, is the equivalent to a Charbonnel crayon No. 5.

For many artists and for the purpose of drawing a test stone, three grades of crayons – soft, medium and hard – are generally quite sufficient. Used like pastels, or sharpened to a point using a blade, a wide range of marks can easily be achieved with variable pressure from light to heavy. Hard *copal* crayons will produce a line similar to that made by an HB pencil, whilst softer crayons will produce a smudgier mark.

Oculus, Robert Peterson, USA.
10 x 12in. (250 x 300mm), 1996.
Lithograph drawn using a variety of grades of crayon and some scraping with a sharp point.
Collection of Paul Croft.

Rubbing blocks

Rubbing blocks look like large crayons, although they are sometimes produced in disc form. Similar in composition, rubbing blocks are also made in three grades – soft, medium and hard. The blocks tend to be highly greasy, however, and a medium-rubbing block will normally be found to be adequate for most work.

Some artists prefer to draw images directly onto the stone using rubbing blocks, since broad expressive marks can easily be achieved. It is more usually applied, however, by smearing some of the crayon on to a soft rag and then rubbing this on to the stone surface. The resulting printed mark tends to be very soft and closely resembles the smudging that occurs in a charcoal drawing. Effective results are achieved when the crayon is applied over a *gum stop out*, where gum arabic is painted on to the stone first and allowed to dry as a mask or stencil. This technique should be tried out on the test stone with the rubbing crayon smeared lightly and also drawn heavily. Bear in mind that rubbing crayon is very greasy and that a little goes a long way.

Welsh Blankets, Thora Clyne, UK. 16.4 x 24.4in. (410 x 610mm), 2000.
A six-colour lithograph printed in five runs, incorporating a blend in one run. The image was drawn using tusche wash mixed with distilled water and crayon.

Gossiping, Clare Bassett, UK,1999.
Lithograph drawn using a variety of different grades of crayon.

Liquid drawing inks

Different brands of liquid drawing inks are ideally used with a dip pen to create pen-and-ink images on the stone. Some of these drawing inks such as Korn's Liquid Paste Tusche and Charbonnel's Encre zincographique are very greasy and will have a tendency to print heavily on the paper, despite looking light in colour when applied. Encre zincographique should normally be diluted with distilled water by up to 50%, whereupon it will take on a brown colour. The palest mark of this solution will appear to reticulate on the stone but will most likely print black; consequently these inks should not be relied upon for tusche effect. They are, however, excellent for producing linear and brush drawings that are to print in a consistent manner.

Tusches

Tusche is perhaps the most distinctive mark-making material available to lithographers, and it is this that makes lithography unique. Basically a greasy liquid ink, it can be used like watercolour to create expressive brushmarks, or applied more heavily to create 'flats' of tone that will print as solid areas of colour. Tusche, however, is most notable for the way in which it generally dries, as it is *puddled* on to the stone and left to dry naturally. As the tusche dries on the stone, particles of grease precipitate out into a reticulated web-like pattern that is highly desirable and is sought after by most lithographers.

The three major companies making lithographic materials supply tusche in a variety of forms: as bottles of liquid, tins of solid paste and as stick tusche, that can then be dissolved and diluted, using distilled water, to the concentrations required. Some of the most popular brands of tusche available include:

Stones Paste Tusche	A paste that contains relatively little grease and is an excellent tusche for producing open reticulation.
Korns Stick Tusche	A paste tusche that is produced in a slab slightly greasier than Stones, although not as greasy as the liquid paste also made by Korns.
Charbonnel Coverflex	A favourite amongst many artists, this paste produces a characteristically dense reticulation.
Charbonnel High Grade	Possibly one of the greasiest pastes available, suitable for heavily drawn or painted images, where reticulation is of less importance, as *filling in* may occur.

Turtle, David Mohallatee, USA. 20.4 x 15.2in. (510 x 380mm), 1994.
Black-and-white lithograph printed using *Noir à Monter*. The image has been drawn
using tusche mixed with dissolved water, crayon, and shop black to create the
border areas of flat. Collection of Paul Croft.

Preparation of tusches

Successful handling of tusche, and the ability to etch and maintain reticulation during printing, is highly dependent upon the careful preparation of tusche *stock* and *working solutions* that are made up before drawing commences. In this way the grease content of the drawn areas can be carefully controlled.

Regardless of which variety of tusche is being used, a concentrated stock solution should first be made, from which further working solutions can then be prepared.

Ideally this should be done at least 24 hours before drawing is due to occur. To make up the solution:

Two Vertical Fish, Hide Ishibashi, Japan. 17.2 x 14in. (430 x 350mm), 1993. A three-run lithograph printed in green, red and purple. The image was drawn using tusche wash and crayon and employs scratching. Collection of Paul Croft.

1. Using distilled water and a clean brush, dissolve some of the paste or stick tusche much in the same manner that you would dissolve watercolour. Do not use tap water with tusche, since chemicals in the water will spoil the solution and it will not reticulate.

2. Initially this may be a slow process. Paste tusches however can be softened overnight by pouring a little distilled water into the tin, enough to just cover the paste. Stick tusches can be rubbed on to a clean saucer and dissolved there.

3. About (1.7oz.) 50ml of a saturated 'stock solution' of tusche should be obtained, such that when painted on to white paper, the resulting mark will appear solid black. Leave the solution to stand for a while until bubbles have settled out.

4. It is standard practice to make up three working solutions from this stock solution – light, medium and dark. There are many set procedures for achieving this, however I have found the following proportions to work well:

Light Tusche	Add about $^1/_3$oz. stock to 1oz. distilled water
Medium Tusche	Add about $^1/_2$oz. stock to 1oz. distilled water
Dark Tusche	Add about $^2/_3$oz. stock to 1oz. distilled water

5. Test each solution on some clean white paper, to check that there is a sufficient differential between them. Stored in airtight jars, the prepared tusches will remain fresh for at least seven days.

6. Each of the concentrations can be puddled on to the test stone using a clean brush and allowed to dry naturally.

Solvent tusches

Curiously, tusches can also be dissolved in a solvent such as turpentine, white spirit or lithotine to provide a quite different range of marks. Solvent washes tend to be very greasy and will print soft, oily-looking marks. Variations can be achieved by painting a solvent wash through water that has already been puddled on to the stone. When the use of solvent washes is anticipated, a separate tin of tusche paste should be reserved for this purpose alone.

Photocopy Toner Washes

In recent years photocopy toner, the black powder used in photocopiers, has been successfully used as an alternative to produce a variety of tusche-like washes. A number of printers, including Nik Semenoff at the University of Saskatchewan[2], have researched the different types of toner available, and have developed useful methods for working with them.

No Regrets Coyote, Gwenllian Beynon, UK. 20.4 x 30.8in. (510 x 770mm), 1995. A four-run lithograph. The image has been drawn using crayon and scratching, tusche wash, a greasy permanent marker pen, and also incorporates a photocopy transfer on the stone.

Natural Growth, Alastair Clark, UK. 14 x 20in. (350 x 500mm), 1997.
A nine-colour lithograph drawn using tusche wash mixed with turps, tusche mixed with water and incorporating photocopy transfer on stone. Colour achieved through reduction printing and monotype.

Santiago Dream, Alphonso Fernandez, Chile. 20.4 x 15.2in. (510 x 380mm), 1994. A black-and-white lithograph drawn using tusche mixed with water, Encre zincographique, crayon, and using considerable scraping with a sharp blade.
Collection of Paul Croft.

Today toner is commonly used as a drawing medium for working directly on to paper, as well as for creating washes in both lithography and screen-printing.

Photocopiers and toners vary considerably, and new products are constantly being manufactured by the major printing companies, so it is likely that some research and experimentation will be required to find a source of toner that will work best for you. Residue or used toner that has already passed through the photocopier is normally required; it can usually be obtained by collecting toner from cartridges that are being disposed of. A jam jar of toner will probably be sufficient for most needs for at least a year.

Although regarded as being totally free of any grease content, toner washes closely resemble tusche. Toner is also capable of producing quite unique reticulation, especially when suspended in a solution of alcohol or surgical spirit, which causes it to form a soft 'pillowy' effect.

A stock solution of toner can easily be mixed by adding about two or three teaspoonfuls of toner to 2oz. (60ml) of distilled water. Mixing is assisted by the addition of two to three drops of liquid soap, which helps to break the surface tension. Further weaker solutions can also be diluted with distilled water if desired. Toner can also be mixed in with surgical spirit or alcohol, again by adding two to three teaspoonfuls to 2oz. (60ml) of solution.

As with tusche, toner is best puddled on to the stone with a clean brush and then dried using a hot hair dryer, which causes the solution to re-ticulate readily. It will be found, however, that the toner, although dry, will not have fixed to the surface of the stone. At this stage it is possible to wipe through the drawing, or it can even be totally removed with a clean cloth.

Toner work needs to be fixed or cured therefore, using either heat or white gas, sold in the USA as 'lantern fuel' and in the UK as standard 'cigarette lighter fuel'.

Curing by heat can be achieved using a very hot hair dryer or a heat gun, applied over the areas of toner until it melts and takes on a shiny lustrous appearance. Alternatively, tip the stone up at a slight angle and pour some lighter fuel over the drawn areas, taking care not to disturb any of the wash. The fuel effectively melts the toner and fixes it on to the stone.

As toner needs to be fixed in either of these ways, it is generally recommended that all toner work is completed first on the stone, with crayon and tusche drawing added later.

Gum arabic and masking fluids

Gum arabic is used extensively in lithography, particularly during etching and even during printing. It can also be used as a drawing medium, primarily as a stopping out agent like masking fluid.

When gum is painted onto the stone it immediately desensitises the stone, preventing the uptake of grease or ink in those areas. Once dry the

Black Tulip, Valerie Hamilton, UK. 14 x 19.6in. (350 x 490mm), 1999.
A black-and-white lithograph drawn using tusche mixed with turps and applied
through water puddled on the stone. Subsequent lightening of certain areas
achieved by honing and also by applying gum etches.

Organica, William Fisher, USA. 12 x 14.4in. (300 x 360mm), 1998.
In this lithograph, part of the image was first screenprinted onto the stone with
asphaltum, and then worked over with crayon in the normal manner. Printed from
a single stone, much of the colour has been added by monotype printing.

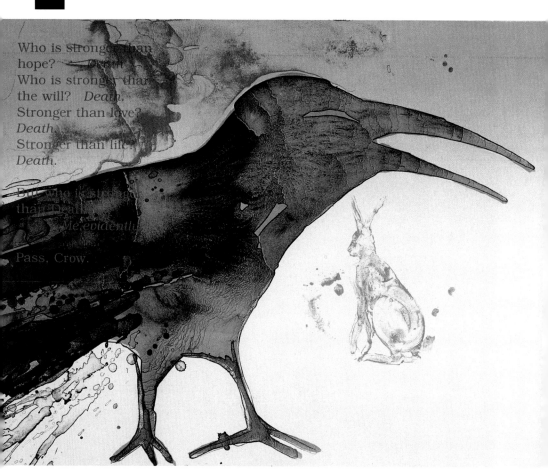

Who is stronger than
hope? *Death.*
Who is stronger than
the will? *Death.*
Stronger than love?
Death.
Stronger than life?
Death.

But who is stronger
than Death?

Me, evidently.

Pass, Crow.

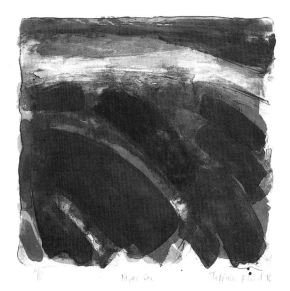

Above:
Klecksographic Series: Crow, Elspeth Lamb,
UK, 22.4 x 30.4in. (560 x 760mm).
Lithograph drawn using tusche mixed
with water.

Left:
Winter Sea, Taffina Flood, Ireland.
8.8 x 11.8in. (220 x 295mm), 1996.
A five-run lithograph printed at the
Graphic Studio in Dublin. Four of the runs
employ an unorthodox method of
drawing using soap washes, whilst the
final run has been drawn using ordinary
tusche mixed with water.

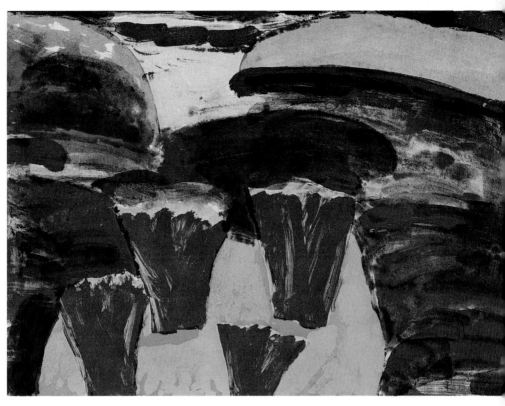

Above:
Hay Ricks by the Sea, William Crozier,
Ireland. 11.2 x 15.2in. (280 x 380mm), 1993.
A four-run lithograph printed at the
Graphic Studio in Dublin. Two runs
employ a soap wash technique whilst
other drawing has been made using
usche wash mixed with distilled water.

Right:
Nonni, Richard Gormon, Ireland.
17.2 x 16in. (430 x 400mm), 1993.
A two-run lithograph drawn with
crayon and tusche wash mixed with
distilled water. Printed at the Graphic
Studio, Dublin.

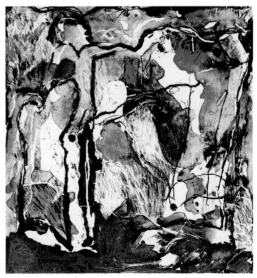

gum can then be over drawn with crayon and rubbing block, resulting in the gummed areas being seen as negative against the drawn marks. Gum can also be sprayed, drawn with a nib pen, or scumbled with a cloth or tissue.

Gum cannot be used in this way with water-soluble tusches, since they will interact with each other and cause an undesirable mess on the stone. In these cases, a standard rubber-based masking fluid can be successfully employed on the stone and overworked with tusche. Once dry, the masking fluid can be rubbed away as normal.

Erasing techniques

A variety of knives, drypoint needles, blades and abrasive materials including sandpaper, hones and Tam O'Shanter Snake Slip Stones can be used to delete drawn areas and to draw through and lighten crayon and tusche. Scratching and scraping can achieve interesting drawn effects similar to burnishing in intaglio printmaking. Excessive overworking in this manner should perhaps be avoided, unless being used as in *manière noire*, since deep scratching of the stone will damage the grain and will result in prolonged graining later.

1 Clinton Adams, *Craystone: The Life and Work of Bolton Brown with a catalogue of his Lithographs*, University of New Mexico Press, 1993.
2 See Nik Semenoff's web site at http://duke.usask.ca/-semenoff/

Chapter 4

PROCESSING THE IMAGE ON THE STONE

Etching and counter etching

 General explanation for etching the stone

Etching is the term used to describe the processing of the stone *essential* if printing is to occur. Although etching generally makes use of acids such as nitric, phosphoric or tannic acid, the term and process should in no way be confused with the *intaglio* process of etching, where zinc or copper plate is corroded through the action of acid.

In lithography, etching a stone or plate is a skilled process that will at first appear to be quite complicated and baffling. However, successful etching can easily be achieved through practice and the accrual of knowledge through experience. Initially it is advisable for the beginner to make careful notes each and every time a stone is processed, recording the strengths of etches applied and noting the resulting success in the printed marks. Completing a test stone or even a series of test stones, working towards the perfection of technique, is a good way to gain such experience of etching and printing images. Soon, etching will become second nature, and will become automatic as confidence develops.

Developing an understanding of the etching process and how and why it works is obviously useful, and I have found that this has certainly helped many students in the execution of the process. Whilst a more detailed and theoretical explanation for etching is provided in the next section, a basic understanding of etching can be gained by considering and noting the following points:

1. Using mixtures of gum arabic and nitric acid to etch the stone, enables the original image that has been drawn (using crayon and tusche etc.) to be removed from the stone, replaced with printing ink. Although lithographic drawing materials and printing ink are both very greasy they are not compatible, and the drawing materials must be replaced with black or coloured ink, to allow the image to be printed consistently.

2. It must be remembered that lithography, unlike intaglio and relief printing, is a planographic process of printing; that is, the

47

image is printed from a totally flat surface. Etching is the process that *chemically* establishes two *diametrically opposed surfaces* on the stone, allowing this flat surface to print selectively, image and non-image areas simultaneously.

3. The principle of lithography is dependent upon the premise that grease and water do not mix. In establishing two diametrically opposed surfaces on the stone, etching in the first instance ensures that all those areas drawn with grease will become more grease attractive or *oleophilic* and consequently water repellent. Simultaneously the etching process also ensures that all of the non-image or negative areas become more water attractive or *hydrophilic* and thus grease repellent.

4. A stone that has been etched to create these two diametrically opposed surfaces can then be inked successfully with greasy printing ink and the image printed. During printing, the stone will be kept damp with water and as such the ink from the roller will adhere only to the grease-attractive areas of the image. Providing that water is present on the hydrophilic surface, the ink will be repelled from the non-image areas and only the image will be inked.

Theoretical explanation for etching the stone

A wholly scientific and categorical explanation for how and why etching actually works upon the stone has as yet never been fully investigated or defined. Every printer appears to have his or her own ideas and interpretation of the process, and as a consequence there are many different approaches to etching. I found, however, that the explanation given below, introduced to me whilst at the Tamarind Institute, was the most convincing and helpful. My own current understanding and approach to etching is based largely upon that knowledge[1].

Etching is achieved by applying mixtures of gum arabic and nitric acid in varying strengths over the drawn image. These mixtures are known as *gum etches* and are formulated by adding drops of nitric acid to 1oz. (30ml) of gum arabic, with each resulting strength being expressed as an *x-drop* etch. The gum etches appear to act on the stone simultaneously in two distinct ways, resulting in the formation of the two diametrically opposed surfaces on the stone.

The desensitising aspect of gum etches
In the first instance, gum arabic appears to have a strong *desensitising* effect upon the stone, rendering it insensitive to grease. Immediately upon contact with the stone, a shell-like molecular layer known as the *gum*

adsorb film is precipitated from the gum coating the stone. The layer is deposited *everywhere* on the stone surface that is *not* occupied by particles of grease from the drawing.

The gum adsorb film is a permanent feature that can only be removed from the stone by either graining or from the application of citric acid during counter-etching. The layer is hydrophilic and, since it attracts water, it helps to ensure that ink is repelled from the negative areas of the image during printing.

Saponification and the creation of a grease reservoir

Gum arabic is itself slightly acidic, having a pH value of around pH4–pH4.5. This acidity, and that of the nitric acid that is added to gum etches, reacts with the calcium carbonate in the stone and also with the grease contained in the drawing materials, in a process known as *saponfication*, creating the soap-like substance called oleo-manganate of lime.

Conveniently, oleo-manganate of lime is formed within the uppermost structure of the stone, directly beneath each and every particle of grease present in the drawn image. As such, a sub-structure copy of the image is created on the stone and since this substance is oleophilic, it is this that allows the image to be inked once the drawing materials are finally removed. Inking the image is also further assisted by the application of asphaltum, a highly greasy substance, which helps to reinforce the image areas.

It is the oleo-manganate of lime that is in fact the ghost image seen during the graining process. Curiously, it would appear that oleo-manganate of lime is self-generating, caused in part by acidity present in the air, and this results in the deeper penetration of the stone by the substance. As a consequence, images that are left to 'rest' after etching tend to be more stable for printing. It also explains why images that have remained upon the stone for a period of months or years will take longer to grain to remove the ghost image than those recently processed and printed.

During the etching process, determining the required amount of nitric acid needed to cause this oleo-manganate of lime to form is a crucial factor. Generally the more grease that is present in the drawing, the stronger etches will need to be. Obviously if too much nitric acid is added and applied, then there is the possibility of seriously burning delicate areas of the drawing.

General overview of the etching process

The etching process is normally completed within two distinct stages, known as the *first etch* followed not surprisingly by the *second etch*. Occasionally a *third etch* might also be required, although usually only if problems occur during printing. Several steps are involved in the process

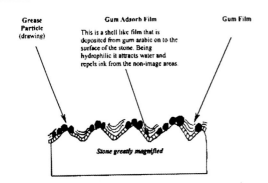

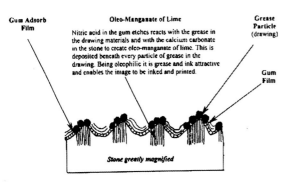

Top: The desensitising aspects of gum etches.
Above: The formation of grease reservoirs.

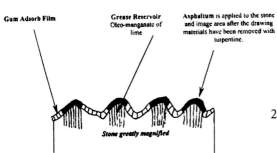

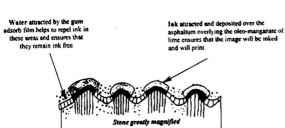

Top: Asphaltum applied after wash out.
Above: Inking the stone.

of etching and these are outlined below and in greater detail in the following section:

1. An initial assessment of how the image has actually been drawn on the stone is made prior to any etches even being mixed. It is important to ascertain exactly how the image has been drawn, and what materials have been used, since this will determine the strengths of etch required. As was suggested above, an area of delicate drawing can potentially be burnt off the stone if too much nitric acid is added to an etch. Conversely, a beautifully reticulated wash might fill in and print as a solid if too weak an etch is used. Most images will tend to vary in quality, being delicate in some areas, and stronger in others. Consequently, many images are normally etched with a range of etches in a process known as *spot etching*.

2. Having assessed the image, unless you are an experienced printer, etch strengths are normally determined with the aid of prepared *etch tables*. Often three etch strengths – weak, medium and strong – are made, although some images may well require further mixes.

3. Etches are applied to the stone as the 'first etch' starting with the weakest etch and finishing with the strongest. This first etch establishes the image on the stone by allowing the gum adsorb film to be deposited and oleo-manganate of lime to be formed underlying the image. After completion of the first etch, the stone is left to rest under a coat of gum for at least one hour, but preferably overnight.

4. The drawn image is then removed from the stone using either pure turpentine or lithotine in a process known as *washing out*. The remaining ghost image is reinforced using asphaltum and then the image is inked up in a black proofing ink using a leather roller.

5. A second etch is then applied to the stone in the same way that the first etch was applied. This second etch essentially helps to stabilise the image for printing by reinforcing the gum adsorb film and creating an opportunity to boost the levels of oleo-manganate of lime.

6. Once the second etch has been completed, the stone is again left to rest for at least one hour, after which it is ready for printing.

Procedure for completing the first etch

In many workshops etching is completed with the stone situated on the press bed. Naturally this is only possible if the workshop is quiet and no other printer requires the press. Otherwise, the stone should be placed on a level bench or table nearby an *inking station*, with access to black proofing ink and a leather roller. While experienced printers can etch stones quickly, it is usually a good idea to allow for at least one hour to complete the first etch. Being well prepared and having all the necessary materials at hand is also advisable.

To complete the first etch on the stone, you will require the following:

- Gum arabic at 14° Baumé.

- Small dropper bottle containing nitric acid.

- A measuring cylinder that allows you to measure 1oz. (30ml) of liquid.

- A number of plastic cups or jars for the gum etches.

- A good quality Japanese or Chinese brush about 1¼in. (30mm) long.

- Rosin and French chalk or talc, and a soft household paintbrush.

- A bucket or basin of cold clean water and a small printer's sponge (gum sponge), trimmed to remove sharp or rough edges.

- Two pieces of clean soft cheesecloth or fine muslin, each about 40in. (1m) square, gathered up into balls.

- Ideally some pH Indicator Papers with a range of pH1.5–pH4.5.

- Access to etch tables if required.

Assessing the image and consulting etch tables

It is important to make a careful assessment of the image before you start etching, so that all the required etches can easily be worked out. Practising with your drawn test stone is a good way to gain experience of the etching procedure under controlled conditions. As a large number of different drawing materials will have been used on the test stone, it will be necessary to mix up a number of different etches (more than would normally be required) and to use these to spot etch the stone.

In determining the strengths of these etches, refer to the test stone and consider the following factors:

1. *The types of drawing materials used to make the image on the stone.*
 The more greasy the drawing material that has been used, the stronger the etch will need to be, requiring more nitric acid. Thus drawing made using a very greasy *Charbonnel No. 5* crayon will require a 'hotter' etch than drawing made using a hard *Korns No. 5* crayon.

2. *The application of materials on the stone.*
 Obviously the way in which crayons or tusche have been used on the stone will also affect the strength of the etch required. A crayon that has been heavily drawn on the stone will probably need a stronger etch than if the same crayon had been used only very lightly.

3. *The hardness of the stone.*
 The hardness of the stone is also an important consideration. Harder stones – grey and dark grey stones – can usually withstand stronger etches than softer yellow or white ones. Marble, for example, will normally require etches that are double the normal strength. Gaining experience with individual stones is the best way to ascertain how each and everyone reacts to etches applied.

4. *Environmental factors.*
 Unless the workshop is kept at relatively constant temperature and humidity, to some extent the climate or weather can affect the etching of stone. The action of nitric acid will become slower in cooler conditions, whilst increased humidity may require that slightly stronger etches are used.

5. *Consulting Etch Tables.*
Etch tables are a valuable reference guide that suggest strengths
for etches (expressed as drops of nitric acid added to 1oz. (30ml)
of gum arabic) to be used on different types of drawing. In this
chapter, I have included three etch tables for *crayon drawing,*
tusche washes and another table for *rubbing crayon* and *pen-and-*
ink images. Etch tables, however, should be used only as a guide,
since environmental factors can substantially affect how etches
react on a stone. Ideally, you should formulate your own etch
tables, using the tables supplied here as a foundation and
adapting them using results from your own test stones
completed.

Etch table for crayon drawing			
Grade of crayon used	**Application of crayon**		
	Light	**Medium**	**Heavy**
Very hard crayon Korns No. 5 Copal Stones No. 5 Charbonnel No. 1 Copal	gum	gum	gum–3 drop
Hard crayon Korns No. 4 Hard Stones No. 4 Hard Charbonnel No. 2	gum	gum–3 drop	3 drop
Medium crayon Korns No. 3 Medium Stones No. 3 Medium Charbonnel No. 3 Medium	3 drop	3–6 drop	6 drop
Soft crayon Korns No. 1/No. 00 Soft Stones No. 1 Soft Charbonnel No. 5	6 drop	6–9 drop	9–12 drop

Etch table for tusche washes

Type of wash used	Application of washes		
	Light $^1/_3$oz. (10ml) stock: 1oz. (30ml) H^20	**Medium** $^1/_2$oz. (15ml) stock: 1oz. (30ml) H^20	**Heavy** $^2/_3$oz.(20ml)+ stock: 1oz. (30ml) H^20
Photocopy toner washes Toner and distilled water Toner and surgical spirit	gum	gum	gum–3 drop
Stones paste tusche and distilled water	gum–3 drop	3–6 drop	6–12 drop
Charbonnel coverflex tusche and distilled water	3–4 drop	5–8 drop	9–15 drop
Charbonnel high grade tusche and distilled water	3–6 drop	6–9 drop	10–15+ drop
Any solvent washes using tusche and white spirit, turpentine etc.	12 drop	15–20 drop	20–25+ drop

Etch table for rubbing crayon, Encre zincographique and honing

Material used	Application of material		
	Light	**Medium**	**Heavy**
Rubbing crayon Hard/Copal	gum	gum–3	3–6 drop
Rubbing crayon Medium	3 drop	3–6 drop	6–9 drop
Rubbing crayon Soft	3–6 drop	6–9 drop	9–12 drop
Liquid drawing ink, Encre zincographique	Use only gum arabic if the lines are to print as black. However use a strong etch such as 15+ drop if you want to obtain tone and reticulation.		
Solid tones and flats of asphaltum	Use only gum arabic.		
Scraping, deletions and honing	Use an etch of around 6–12 drops applied directly to the deletions made.		

Gum etches drops/pH value

Drops	pH Value	Drops	pH Value
1	3.8–3.4	16	1.1–0.8
2	3.5–3.2	17	1.0–0.8
3	3.4–3.0	18	0.9–0.7
4	3.1–2.8	19	0.9–0.6
5	2.9–2.5	20	0.9–0.6
6	2.7–2.3	21	0.8–0.5
7	2.5–2.0	22	0.7–0.5
8	2.3–1.8	23	0.7–0.5
9	2.0–1.6	24	0.6–0.5
10	1.8–1.4	25	0.6–0.5
11	1.7–1.3	26	0.6–0.4
12	1.5–1.2	27	0.6–0.4
13	1.5–1.1	28	0.6–0.4
14	1.4–0.9	29	0.6–0.4
15	1.3–0.9	30	0.6–0.4

Determining etches for light areas of drawing

When assessing the image, first of all determine which areas are the 'lightest' parts containing the least amount of grease. On the test stone these will probably include any drawing made using a hard crayon (such as *Korns No. 5*), photocopy toner washes, and light tusche washes. Make a written note of what these are and then consult the relevant etch tables to ascertain which etches are required. For this type of drawing, probably just pure gum arabic with no nitric acid will be adequate for the etch. However, if a particularly greasy brand of tusche such as *Coverflex* or *High Grade* has been used, it may be necessary to use a *3-drop* etch. This can also be applied to any heavily applied hard crayon and to any lightly applied rubbing crayon.

Determining etches for heavily drawn areas

Next determine which areas of the image are the most heavily drawn, containing the greatest amount of grease. On the test stone these will probably include any drawing using a soft crayon (such as *Charbonnel No. 5*), any heavily applied rubbing crayon, and dark tusche washes.

Consulting the etch tables for these types of drawing will suggest an etch of between 9 drops and 12 drops will be required. However, if particularly greasy brands of tusche have been used it may be necessary to

use stronger etches of between 9 and 15 drops. Solvent washes normally require etches in excess of 15 or 20 drops, since the solvents themselves tend to be very greasy.

Determining etches for medium drawing or middle tones

The same procedure is used to determine the strength of etches required to etch areas of 'medium drawing'. On the test stone these will include any drawing using medium crayon (such as *Korns* or *Charbonnel No. 3*), most rubbing crayon that has been smeared on to the stone, and medium tusche washes.

Consulting the etch tables for these types of drawing will suggest an etch of between 3 drops and 6 drops will be required, unless of course particularly greasy brands of tusche have been used.

It will normally be found that most images can be etched using just three strengths of etch. Test stones however do tend to require additional etches, and for this I would normally use etches of: gum, 3 drops, 6 drops, 9 drops, 12 drops and occasionally a very strong etch such as a 15 or 20 drop.

Mixing the etches

Fresh etches should always be mixed up before they are applied to the stone; it is not normally a good idea to save or store etches from etching one stone to the next.

Etches are always made by adding drops of nitric acid to 1oz. (30ml) of gum arabic, mixed up in an appropriate jar or measuring cylinder. Having worked out how many etches will be required, measure out 1oz. (30ml) of gum into each of the jars being used.

Caution should always be observed when handling nitric acid, and contact with skin and inhalation of fumes should always be avoided. Drops of nitric acid should now be added to each of the jars, using either a pipette or pouring the acid gently from an acid dropper bottle. Add the required number of drops to each of the etches. For example, the weakest etch may have 3 drops of acid, the medium etch 6 drops of acid, and the strongest perhaps 9 drops.

The acid, when it is added to the gum, must be well mixed, using a stirring stick to ensure that an even dispersal occurs throughout the etch. It is also a good idea to label each of the etches since they can easily be mistaken for each other.

Since drops of acid themselves can vary in size, some printers find it desirable to check the acidity of each of the etches mixed using some pH-indicator papers and consulting a *pH-to-drop* table of values.

Applying rosin and French chalk

Before etches are applied to the stone, the image is first dusted with rosin and French chalk or talc. Rosin is the same acid resistant resin dust used in aquatinting in intaglio printmaking. The rosin sticks to the greasy drawing and helps to protect the image from the excessive rigour of the nitric acid in the etch. It is applied to the stone using a soft household paintbrush, and the excess brushed off. French chalk or talc is then applied in a similar manner. The chalk effectively helps to break the surface tension and ensures that the gum etches make close contact with the drawing and the surface of the stone. Any excess should also be brushed off from the stone.

Applying resin to the stone for etching.

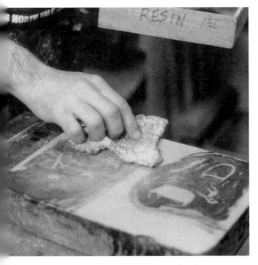

Dusting the resin across the image.

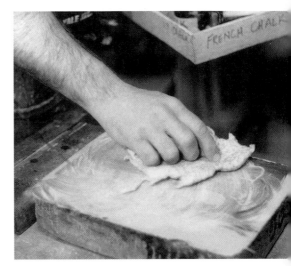

Applying French chalk.

Measuring out 1oz (30ml) gum arabic.

Pouring out drops of nitric acid.

Applying a thin gum coat across the stone in preparation for etching.

Applying the first etches

Etches are always applied starting with the *weakest* etch and finishing with the *strongest*. Etches are normally applied through a thin layer of wet gum, known as a *gum coat*, and ideally using a Japanese or Chinese calligraphy brush (used only for this purpose) for spot etching. To complete the first etch:

1. Apply fresh gum to the stone, spreading it evenly and thinly across the surface, using either your hand or a clean *gum sponge*, and taking care not to disturb any of the more delicate parts of the drawing. This gum should be maintained as a thin wet film throughout the first etches, as it acts as a gum coat through which subsequent etches are applied. It also represents the weakest etch that is applied to the stone, etching such areas as toner wash, lightly applied hard crayon and the weakest areas of tusche.

2. The weakest etch mixed (probably a 3 drop) is now applied to those areas of the drawing that require it, such as more heavily applied hard crayon, light tusche washes and weaker areas of smeared rubbing crayon. The etch should be puddled over the respective drawn areas with the brush, and allowed to remain on the stone for about 60 seconds. Etches tend to act on the stone within this time unless the temperature is particularly cold. After this time, the etch should be picked up with the gum sponge and the gum coat replenished with fresh gum.

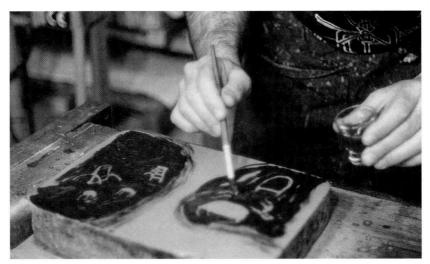

Spot etching with a weak etch.

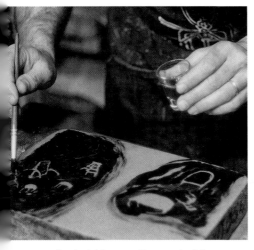

Spot etching another part of the image using a stronger etch.

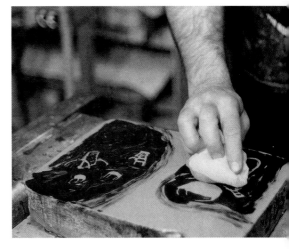

Buffing down the gum coat tight with cheesecloth after etching.

3. This etch is then reapplied in the same way simply to ensure that all of the relevant areas have been treated.

4. The following strength of etch (probably a 6 drop) is now applied in the same way to etch such drawn areas as medium crayon, heavily applied rubbing crayon and medium tusche washes. Again the etch is carefully puddled over these areas using the brush and allowed to remain on the stone for about 60 seconds. As stronger etches are used, care should be taken not to wipe or leak these into the more delicate areas of the drawing, especially when lifting the etch from the stone, since this could cause burning and inevitable loss of image.

5. As before, this etch should be reapplied to ensure that all relevant areas have been treated.

6. Finally, the strongest etch (perhaps a 9 or a 12 drop) is applied to such areas as heavily applied soft crayon and dark areas of tusche. Stronger etches tend to react on the stone more noticeably, with a visible *effervescence* occurring about 30 seconds after the etch has been applied. If bubbling occurs immediately, however, then the etch is too strong, should be removed at once and fresh gum applied immediately, otherwise the drawing may become burnt. Sometimes a strong effervescence is desirable when etching very heavily applied tusche washes, where *etching for effect* helps to maintain the reticulation and keep such washes 'open' during printing.

7. Once the strongest etch has been removed from the stone, fresh gum is applied to help neutralise any remaining acidity. With the gum coat thin, soft cheesecloth, gathered up into a ball, is used to gently buff the gum down as tight as possible without smudging the image. If necessary, use a second piece of cheesecloth to gently polish the surface.

8. This completes the first etch on the stone. The stone should be left to rest for at least one hour but ideally overnight. All sponges and cheesecloths should be rinsed out and any remaining etches disposed of.

Washing out and rolling-up the image

With the first etch complete, the intention now is to remove the drawing materials from the stone and to replace the image with printing ink. This procedure is known as *washing out* and *rolling-up* and while this can be done with the stone on the press bed, ideally the stone should be situated

on a bench alongside an inking station, with access to proofing ink and a leather roller. For completing wash out and roll up, you will require the following:

- Gum arabic at 14° Baumé.

- Pure turpentine or lithotine.

- Liquid asphaltum.

- Soft clean cotton or linen rags.

- Two pieces of clean soft cheesecloth or fine muslin, each about 40in. (1m) square, gathered into balls.

- A bucket or basin of clean cold water and two printer's sponges trimmed to ensure there are no sharp edges.

- A leather roller in good condition and well scraped back, and a clean inking slab.

- Black proofing ink such as Graphic Chemical Company's roll-up black.

To complete the wash out:

1. Prior to washing out the image, it is important to re-gum the stone. This ensures that the gum coat has been buffed down tight and thin over the image; a thick coat of gum on the stone would inhibit washing out of the image. Spread fresh gum evenly over the whole stone and buff this down tight, using soft clean cheesecloth, polishing it well like a piece of furniture.

2. Apply pure turpentine or lithotine to the stone and, using a soft clean rag, gently wash out the image. It is important not to rub too vigorously – some areas of the image, such as toner wash, may be slow to disappear but will do eventually. Wipe away any excess turpentine and debris from the stone.

3. Liquid asphaltum is now applied to the stone. Asphaltum, sometimes known as *wash out*, is a viscous and very greasy substance that can, if necessary, be used to help remove stubborn areas of drawing. It is more commonly used, however, to help reinforce the image area prior to inking. Apply a little asphaltum on the stone and, using a clean soft rag, spread this evenly over the whole of the image, avoiding streaking, and buff it down until it appears a light golden brown.

The stone is always rolled up using a non-drying black ink, sometimes known as *proofing black*, *roll-up black* or *shop mix*. There are a number of different brands available such as Graphic Chemical Company's Roll-up

Black and Yorkshire Printmaker's Proofing Black, amongst many others. Roll-up ink needs to be quite greasy to help reinforce and build up the image at this stage, and it needs to be non-drying, since the inked image itself will be washed out at a later stage prior to printing. The ink is rarely used for actual printing and is always rolled out with a leather roller.

Occasionally, if an image contains very delicate drawing or finely reticulated washes that would fill-in at this stage, another stiffer ink might be mixed in with the roll-up black. Inks such as Graphic Chemical Company's Senefelder Black or Charbonnel's Crayon Black might be used in this scenario.

To roll up the image in roll-up black:

1. Ensure that the roll-up black is rolled out to a thin, even film on the inking slab, and that the roller is charged and ready to roll.

2. It is important that a *lean* ink film is first established on the stone, and the image built up slowly with successive rolling. If too much ink is applied initially, there is the potential for the image to become overinked, and for filling-in to occur.

3. Using a damp sponge, the gum coat on the stone with the overlying asphaltum is *washed off*. It is important to work quite quickly at this stage and not to allow beads or puddles of water to settle on the image, since the water itself can easily damage the asphaltum and cause *water burn*.

4. Excess water and any remaining debris should be removed promptly, using a second well wrung-out sponge. The asphaltum image will now be seen clearly on the stone and is ready to receive ink.

5. With the stone kept moist with water, the leather roller is rolled across the stone brusquely, to deposit ink on the image.

6. The stone will need to be re-dampened after a few rolls. Use a wet sponge to dampen the whole surface of the stone, then a well wrung-out sponge to keep the water film thin and even. Obtaining a good balance of water on the stone is important and requires careful sponging, so that the stone is neither too wet nor too dry.

7. *Dry roll* occurs when the stone is dry and ink is deposited in the negative areas as well as on the image. If this occurs, quickly re-dampen the stone and roll vigorously to remove the ink from those areas.

8. The roller too will probably need to be re-charged after each pass over the stone. Keep the stone damp during inking and use the

roller in a methodical way to ensure that the whole of the image is inked up evenly.

9. It should take a while for the image to ink up in normal circumstances. The image will be considered fully inked when the strongest areas of the image appear full and 'glisteningly black'. Once this has been achieved, the stone is fanned dry and is ready to receive the second etch, which should be completed as soon as possible.

The second etch

With the image now converted to ink, the etching process is completed with a final second etch. Whereas the first etch is used to establish the image on the stone, the second etch is used to consolidate and stabilise the image for printing. During this second etch the gum adsorb film, which is sometimes weakened through the abrasive activity of rolling up, is reinforced, while a further opportunity is provided to boost the levels of oleo-manganate of lime underlying the image areas.

Assessing the image and determining etches to be used

The procedure for the second etch is exactly the same as for the first. Determining the etch strengths that are required for the second etch, however, is very much dependent upon how the image now appears under black ink.

The image is exactly right!

On most occasions the image will have inked up exactly as was intended, with a full range of tone, detail and definition. There may have been some loss of very light drawing and some reticulated washes may have opened up somewhat. Equally some areas of the drawing may now appear fuller or richer as an inked image but, on the whole, the image will have been satisfactorily processed.

In this scenario, the first etch will have been wholly successful and the same strengths of etch should now be used in the same way for the second etch. Sometimes the etch strengths can be reduced slightly, (e.g. using a 5 drop instead of 6 drop) if the image has opened up a little in some areas.

The image is heavy and dark

Sometimes, however, the image will have inked up quickly and more heavily than was intended. Crayon drawing, instead of being crisp and clear looking might appear heavy and globular, while washes may have filled in, losing their reticulation. In this scenario the range of tone will have reduced and the whole image will appear very dark.

This situation sometimes occurs if the image has been over-inked or an excess of asphaltum has been used. Sometimes it is worthwhile to perform a *wet wash* to remove the existing ink from the stone, and to then replace it with a leaner and possibly stiffer ink. To do this:

1. First of all clean the inking slab, scrape back the leather roller and then roll out a much leaner ink film, perhaps using a stiffer ink.

2. Damp the stone with copious amounts of water. Using a clean rag to wash the image out quickly, using turpentine or lithotine, and then apply asphaltum with another rag and buff this down into the image.

3. Use a damp sponge to quickly remove any excess water, asphaltum and debris and then quickly roll up the image, using the stiffer and leaner ink, until it appears satisfactory and full.

If, however, the image continues to appear heavy then it is more likely that the etches used for the first etch were far too weak and the stone was *under-etched*. Consequently, the etches used for the second etch should be increased (e.g. using a 9 drop instead of a 6 drop) and this will help to open the image up and stabilise it for printing. If some washes have almost totally filled in, it is sometimes possible to open them up again using a very strong etch and *etching for effect*.

The image is very light

On the other hand the image may have been very slow to ink up, with some areas appearing light and, worse, some parts even disappearing. Definition and detail will have diminished, washes will appear weak and some areas may seem burnt looking.

Unfortunately in this scenario, the etches used in the first etch will have been too strong and the image will have been *over-etched*. Assuming that damage is limited, the etches used for the second etch should be reduced drastically (e.g. using gum instead of a 6 drop!). If, however, large parts of the image have disappeared then sadly the options are to counter-etch the stone and redraw those areas or, alternatively, the stone should just be re-grained and started afresh.

Having determined the etch strengths required, the second etch should be completed in the same manner as the first. Apply rosin and French chalk and apply the etches through a gum coat, starting with the weakest etch and finishing with the strongest. Once the second etch has been completed, the gum coat should be buffed down in the usual manner and the stone left to rest for at least one hour. It will then be ready to print.

Counter-etching stone and making deletions

Having etched the stone, and certainly once the image has actually been proofed in black, it is not uncommon for alterations to be made in the form of additions and deletions. After the second etch the drawing on the stone may seem to have changed subtly, as ink will now have replaced the drawing materials originally used. In some circumstances, where over-etching has occurred, there will be a need for redrawing and additional tone or washes. In other cases you may simply want to add further elements to the image or, conversely, you may want to remove mistakes, smudges or even erase whole areas of the drawing.

Although seen primarily as corrective measures, additions and deletions can also become a deliberate part of the creative experience. Picasso in his *Bulls* series, for instance, made use of deleting and counter-etching to substantially alter the image through twelve stages, printing each state as an edition and transforming a quite naturalistic image, through cubist form, and concluding with a simple minimalist statement.

Etching of course desensitises the stone through the formation of the gum adsorb film and any further application of greasy drawing materials will naturally be repelled. Consequently, the stone must be re-sensitised by the process of counter-etching. Deletions can of course be easily achieved using a series of hones, blades and even using carborundum.

Counter-etch solutions

Removal of the gum adsorb film can be achieved by using an appropriate counter-etch solution such as either dilute acetic or citric acid. Although counter-etching can be carried out after the first etch, it is normally better to wait until after the second etch, and ideally after the image has actually been printed. Only ever counter-etch an image that has been inked. Although very weak solutions of acetic or citric acid are used, both are corrosive and can potentially damage an existing drawing and even attack the granular structure of the stone if used incorrectly.

There are many quite elaborate recipes for counter-etch solutions, but dilute acetic or citric acid are probably the simplest to apply. Acetic acid counter-etch can be mixed up as a stock solution and stored in an airtight bottle until it is required; citric acid should be mixed only when it is about to be used. Many workshops in the USA prefer to use citric acid since this can be used to counter-etch aluminum plate as well as stone.

Acetic acid counter-etch solution

To make up a stock solution of acetic acid, add 1 part acetic acid to 9 parts distilled water and store this in an airtight bottle. This solution can be further diluted by up to 50%, adding 1 part stock solution to 1 part distilled water, used in this way if the image being counter-etched contains especially delicate drawing or washes.

Citric acid solution

To mix up citric acid counter-etch, add one quarter teaspoonful of anhydrous citric acid powder to 10oz. (300ml) distilled water and heat in a microwave until it is about 176°F (80°C). Use immediately before the solution cools appreciably.

Procedure for counter-etching the stone

For counter-etching you will require:

- About 10oz. (300ml) of counter-etch solution.

- A clean printer's sponge used only for counter-etching. Never use a sponge that contains even the slightest trace of gum arabic.

- A large clean soft household paintbrush used only for counter-etching.

- Rosin and French chalk or talc.

- Some fresh sheets of clean newsprint.

- A hair dryer or a flag for fanning the stone dry.

Counter-etching normally occurs with the stone placed on the graining sink, with access to running water and drainage. Whilst it is possible to counter-etch selected areas of the image that require redrawing, it is sometimes as easy to counter the whole stone.

To counter-etch the stone:

1. Assuming that the image has been fully inked, apply rosin and French chalk and dust off the excess. (If the stone has been gummed down tight, rinse the stone with water to remove the gum coat, blot the stone and fan dry).

2. Apply about 5oz (150 ml) of the counter-etch solution to the stone and move this continuously across the surface, using a soft clean household paintbrush.

3. After about two minutes use the well wrung-out sponge to mop up the counter-etch from the stone.

4. Rinse the stone well with water and then blot the surface with some clean sheets of newsprint. Using a hair dryer or flag, fan the stone dry.

5. Reapply a further 5oz. (150ml) of the counter-etch solution in exactly the same manner as before. Ensure that the stone is well rinsed with water, blotted and dried.

Redrawing and etching additions

Unless a radical change in the image is being contemplated, it is normal for any new drawing added to be matched with that already existing on the stone. The newly drawn marks should blend in, following as closely as possible the intentions of the original statement in terms of mark, weight and style.

However, drawing on the counter-etched surface of the stone tends to be fragile and to compensate for this, additions should be completed using more greasy drawing materials and drawing more heavily than normal. Whereas a hard crayon might have been used in the original drawing of the image, a medium crayon should now be used and a heavier tusche should replace weaker washes.

Previously etched areas of the image can be treated with gum arabic but the newly completed additions will need to be etched twice. Note, however, that drawing materials applied after counter-etching are barely attached to the stone and etch strengths used for the first etch should be markedly reduced by at least 50%. Second etch strengths can then be formulated as usual, depending upon how the stone rolls-up.

Deletions on the stone

Corrections involving deletions on the stone can be made using knives, drypoint needles and blades. Commercially produced hones, erasing pencils made of rubber impregnated with pumice, Tam O'Shanter Snake Slip Stones and Benders Etchosticks that are a weak caustic abrasive are also excellent.

Deletions can actually be made at any stage in lithography and many artists like to use deletion in a creative way, scratching and scraping through crayon and tusche to create interesting drawn effects similar to burnishing in intaglio printmaking. As with additions, deletions must also be etched, otherwise there is a tendency for the erased areas to continue attracting ink and to fill in during printing. Etch strengths required tend to depend upon how greasy the drawing was before it is was deleted. Normally a first etch of between 6 and 10 drops is adequate for maintaining clean deletions.

1 Clifford Smith, Educational Director at the Tamarind Lithography Workshop 1969, 'A Theory of the lithographic etching process: stone', from *The Printer Trainer's Handbook* provided for the professional Printer Training Programme at the Tamarind Institute, 1994.

Chapter 5

PROOFING THE STONE IN BLACK

 Proofing images in black

Proofing is the term used to describe the process of *trial printing* an image, and derives from the printer's practice of *proving* a plate, block or stone to enable the artist to see how well his or her image appears printed on the page. In intaglio printing, for instance, *state proofs* are frequently made following additions, deletions and corrections made by the artist. In most print publishing workshops the printer aims to pull the optimum proof that, once approved by the artist, becomes the *approval to print* and a benchmark for the edition.

In lithography it is common practice to proof the stone in black, to obtain just a couple of proofs, even if that drawn image is intended as a *key image* and may in fact finally be printed in colour. From this proof, subsequent plates or stones can then be drawn up to print *colour runs*, with the key image printed last to 'tie the image together' at the end. In colour printing, experience of *colour trial proofing* will be gained, where the process of printing a number of different plates and stones in varying orders and using varying colours can also be tried out.

Proofing in black is important as it allows you to see how the image appears on the paper. It also gives a good indication of how well the image has been etched and how stable it is for editioning, suggesting whether a third etch is needed. Printing in itself also helps to strengthen the image areas, by quite literally forcing the oleo-manganate of lime underlying the image deeper into the stone.

Printing in black is generally regarded to be easier than using colour and so useful experience in inking, rolling and achieving consistently correct inking levels from one print to the next can be accomplished at this stage; valuable experience of handling paper, sponging and operating a press are also important and will develop good working practice for subsequent editioning of prints.

Opposite:
Wind Chime Shrine, Paul Croft, UK. 20.4 x 15.2in. (510 x 380mm), 1994.
Black-and-white lithograph, drawn with crayon and tusche.
Printed by David Mohallatee.

As in all aspects of lithography, good working practice and successful printing is largely dependent upon good preparation. This necessarily includes paper preparation, tearing paper, calendering it if this is necessary and setting registration marks, all of which can be completed in advance. Press preparations include setting up on the press and preparing ink and other materials.

Assuming that you are well prepared for printing, the time required to print two or three proofs in black should realistically take only half an hour and certainly no longer than one hour.

Paper and paper preparation

Types of paper

A huge range of printing papers, both mould-made and handmade are available in a range of colours, thicknesses, textures and finishes. Proofing provides an ideal opportunity for testing papers and determining which type of paper is most appropriate for the image. Whilst many types of papers can be used for lithography, generally a smooth and absorbent acid-free paper is desirable since this will accept ink, definition and detail most favourably.

Most mould-made and handmade papers will have one or more natural deckle edges and a watermark signifying the paper type. Paper also has a front and a back, and care should always be taken to print on to the front side of the sheet. This front side can usually be identified from the watermark, which is always readable from this side. The reverse side of the paper may have a fine woven texture resulting from the screen mesh used to make the paper.

Some of the most commonly used papers in lithography include:

- Rives BFK – supplied in a variety of colours including white, cream, grey, tan and available in weights of 180g/m^2 and 250g/m^2.

- Velin Arches – a slightly rougher and more textured paper that may require calendering; available in white, cream and black in weights of 200g/m^2 and 250g/m^2.

- Fabriano Rosapina – supplied as white and ivory (which has a slightly pinkish hue) in weights of 220g/m^2 and 285g/m^2.

- Hahnemühle or German Etching Paper – an excellent paper supplied in white and natural (which has a slightly greenish tint) in weights of 300g/m^2 and 350g/m^2.

- Somerset – produced in a range of colours and finishes including satin, velvet and textured. Somerset satin white is

possibly the whitest paper available for printmaking, in weights of 250g/m^2, 280g/m^2 and 300g/m^2.

- Zerkall – produced in a range of colours and finishes, including a laid version.

In addition to these, many other papers and materials exist. Prints can be made on to silk, cloth, plastics and acetates, tracing papers and tissue. A good example of a series of prints using matt mylar and tracing papers printed and collaged, is that of the New York artist Suzanne McClelland, whose work was printed by Frank Janzen at Tamarind in 1995. A large variety of Japanese, Chinese and ethnic papers may also be utilised.

Thin Japanese papers such as Mulberry and Gasen are often printed on to first and then are used as *chine collé*, adhered to a thicker supporting sheet of mould-made paper. The print *Extension* by Clinton Adams was printed in this manner, being first printed on to natural Sekishu and subsequently adhered to a sheet of Somerset Satin.

Tearing paper to size

All the paper that is to be used should ideally be prepared well in advance of printing, perhaps even the day before. For proofing an image at this stage it is a good idea to aim to print at least two or three prints – perhaps making use of a different type of paper or colour for each.

The paper being used to print on should obviously be large enough to carry the image, but must also be smaller than the size of the stone, so that registration marks can be easily matched and each sheet placed over the image in the correct position. (In certain circumstances, paper larger than the stone can be used, but this will require a more complicated method of registration and ideally should be avoided.)

Paper should always be torn to size, avoiding cutting with a knife or paper cutter and taking care to preserve the natural deckle edges wherever this is possible. Whenever large numbers of sheets are being torn, for an edition, then each sheet should as far as possible be torn identically, so that watermarks and deckle edges appear consistently from one sheet to the next.

Ideally all paper tearing should be carried out on a clean table reserved only for this purpose, to ensure that the paper is kept clean and free of blemishes. Never fold the paper and always tear from the back against a clean metal straight edge. Some papers, such as Fabriano, should first be scored with a sharp stylus before they are torn to avoid creasing, and some Japanese papers are more easily torn when they are first dampened with a clean brush along the edge that is to be torn.

Some papers, such as Velin Arches, have a rough texture that can inhibit the printing of fine detail, whilst others may have a tendency to stretch, by up to $\frac{7}{16}$in.(10mm), causing problems of registration. If these problems are

anticipated then calendering the paper by running each sheet through the press twice under printing pressure, will help to smooth and pre-stretch the paper.

Some printers follow traditional practice and print onto damp paper. Although this certainly helps to increase the absorbency of the paper, resulting in richer, fuller looking prints, dampening will cause problems of expansion and contraction, and this will affect registration, especially during colour printing. Printing onto dry paper is therefore preferable and this can be easily achieved using a little more pressure during printing.

Centering and T-bar registration

Once all the paper has been torn to size, T-bar registration marks are then made on the reverse side of each sheet of paper. These marks are always made at the mid-points along the top and bottom edges of the paper using a sharpened HB pencil.

Adding T-bar registration marks to the reverse side of each sheet of printing paper. Bar marks are normally made along the natural deckle edge of page while T-marks are placed along the torn or cut edge. For fine registration, a razor T-mark can be made by shaving the paper edge with a blade at that point.

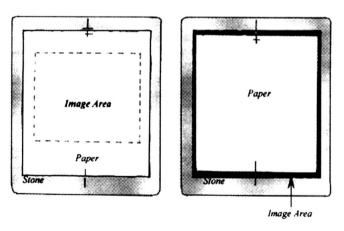

Image with a border Bleed print

Setting the T-bar registration marks on the stone.

To make the T-bar marks:

1. Stagger the torn sheets, printing side face down, so that they lie centred over each other with about ⁹⁄₁₆in. (15mm) of the deckle edge end of each sheet showing.

2. Using a centering ruler, mark the mid-point across the width of each deckle edge showing. Then with a straight edge, draw a line across the staggered edges so that a small line extends to the very edge of each sheet. These marks are known as bar-marks and normally indicate the lower edge of the paper, which usually retains the natural deckle edge.

3. Now rearrange the paper in a similar manner to expose the top edges of each sheet, which are usually torn or cut edges and mark the mid-points in the same way as before.

4. These bars are then crossed to form 'T's, indicating the upper or top edge of each sheet.

Setting the registration marks on the stone

Normally registration marks will have already been cut on the stone during drawing. Sometimes, however, this will not have occurred and some printers prefer to add these marks at this stage. T-bar marks can easily be transferred to the stone using a sheet of tracing paper, mylar or acetate, that has the 'paper area' and registration marks already fixed on in pen or pencil.

To set the registration in this way:

1. First of all lay a sheet of acetate on top of one of the sheets of torn paper that is to be used for printing and trace this and the T-bar marks with a pen.

2. Now place the acetate on top of the stone, positioning it so that the image seen through the film is centred appropriately within the marked out paper area. It is a good idea to tape the acetate in position with some masking tape.

3. Using a sharp knife or razor blade, cut the T-bar marks through the acetate onto the stone, as precisely as possible, remembering not to score the stone too deeply.

4. Now take the acetate away and rub a little gum arabic into the cut marks, to ensure that they will not ink up and print.

Setting up on the press

Types of presses

Two main types of presses are used for printing lithographs and these are described as being either *indirect offset presses* or *direct flat bed presses*. The offset presses were developed for commercial printing of plates and characteristically have two beds, one for the plate and one for the paper. The inked image is transferred from the plate by a large roller, which picks up the image as it passes over the plate and then prints it onto the paper as it travels across. The main advantage of offset lithography, apart from the potential for a fully automated system, is that the image is printed the 'right way round'.

Although some offset presses are capable of printing stone, normally a direct press with a single bed carrying the stone is used. Printing occurs when the inked stone, with the paper placed on top and protected by a greased tympan, travels beneath a centrally mounted scraper bar, which exerts pressure on the paper. Unlike offset lithography, the image printed is reversed.

Many workshops today still use some of the old (antique) *side-lever presses,* such as the British *Furnival* and *Grieg* presses. These presses use a side lever to operate a crankshaft which lifts the press bed up beneath the scraper bar and forces the stone to travel through under pressure.

More modern machines, such as the American *Takach, Charles Brand* and *Griffin,* and a new model made by the Dutch firm *Polymetaal,* use a *top-lever* system that exerts pressure by lowering the scraper bar on to the tympan.

Both side-lever and top-lever presses are excellent for printing stones and plates and both types can be either power operated or manually driven. Advocates of the newer top-lever presses, however, would claim that these are probably more sensitive to operate and are less likely to cause stones to fracture.

Setting up on the press

Well-organised workshops will have a press situated alongside an inking station reserved for printing, together with plenty of clean bench space to lay out proofs as required. There should also be a good supply of scraper bars of varying lengths available. Scraper bars are the crucial component that actually exert pressure during printing. Traditional scraper bars were made from strips of oak or hard maple covered with a leather brace, while contemporary versions are made from polyethylene covered with a thin polyethylene strip. These bars are precision made and their printing edges must be cut to an accurate angle for optimum printing to occur. The bars should be treated carefully, and denting and nicks in the scraper blade should be avoided.

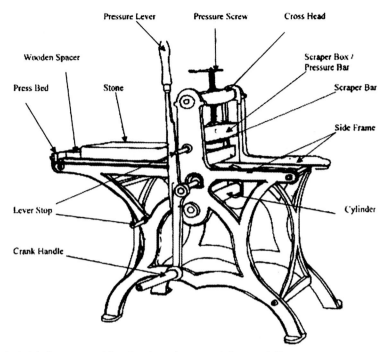

Typical side-lever press (drawing based upon a Grieg model)

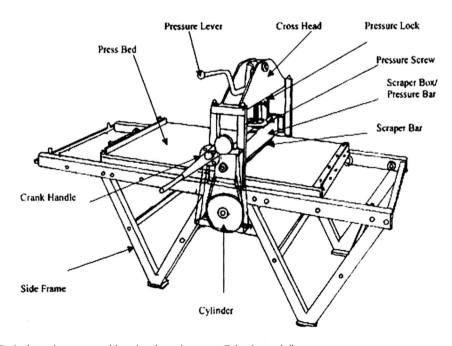

Typical top-lever press (drawing based upon a Takach model)

The traditional brass tympans that were a feature of many of the older presses have largely been replaced by hand-held polycarbonate sheets that are extremely durable and do not stretch or shatter under pressure. The tympan is used to cover the stone and protects it as it is printed. Grease applied to the upper surface enables the stone to slide effortlessly beneath the pressure of the scraper bar.

Regardless of whether a side-lever or top-lever press is being used, the procedure for setting up on the press is very much the same. Always ensure that the stone and the press are ready for printing before rolling out any ink.

To set up on the press:

1. Place the stone centrally on the press bed, with the T-mark edge of the stone facing towards the scraper bar. The bar-edge of the stone should be brought up flush against some *spacers*, (short planks of wood set at the end of the bed, that ensure the whole length of the bed will not have to travel through the press during printing). There should also be equal space to the left and to the right of the stone.

2. Select a suitable scraper bar. This needs to be wider than the printing paper being used but not any wider than the stone.

3. Centre the scraper bar on the pressure bar of the press and lock it in to position. Check to see that the ends of the scraper bar do not over run the edges of the stone; adjust the position of the stone and/or the scraper bar accordingly.

4. Raise the pressure bar by adjusting the pressure screw on the press, turning it counter-clockwise until the scraper bar has been raised well above the level of the stone, effectively 'turning off' any pressure.

5. Now the *start-stop positions* for the press bed need to be set. These relate to the positioning of the stone beneath the scraper bar at the start and finish of printing. On most power-operated presses, adjustable magnetic markers found on the side of the press bed automatically start and stop the press as required. On manual presses, however, these positions are usually marked with tape on the press bed and are then aligned with a mark made on the press frame as the bed travels through the press.

6. In either system, the *start marker* needs to be set such that the T edge of the stone lies directly beneath the scraper bar as printing begins. The *stop marker* then needs to be set to ensure that the scraper bar will not run off the bar end of the stone at the finish of printing.

7. The pressure can now be set on the press.

(a) First place two sheets of clean newsprint on top of the stone and then place the tympan on top, with the greased side facing up.

(b) With the pressure lever disengaged, move the press bed until the stone lies about halfway through the press and the mid-point lies beneath the scraper.

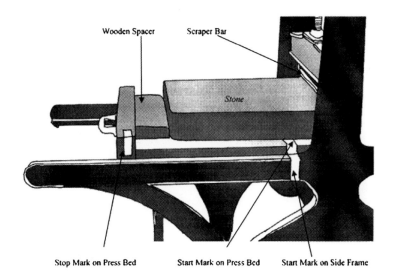

Starting position with the T-end of the stone lying directly beneath the scraper bar.

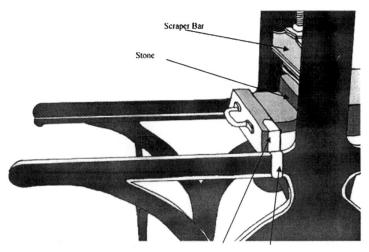

Stop position with the bar-end of the stone lying directly beneath the scraper bar.

(c) Now engage the pressure lever, either lowering the scraper or raising the bed. There will of course be no pressure felt at this stage.

(d) The initial printing pressure is set by turning the pressure screw clockwise, lowering the scraper bar on to the tympan. Turn the screw until it is impossible to turn it any further and the scraper bar is sitting firmly on the tympan. Now lift the pressure lever again to release the pressure.

(e) With the pressure disengaged, the pressure needs to be increased by at least ½–¾ turn of the pressure screw, although this will certainly vary with different presses.

(f) Engaging the pressure lever again, considerable pressure will now be felt. This pressure should also be checked with the stone in the start and in the stop positions to ensure that it is consistent.

Setting pressure on presses requires experience with individual machines, since they do tend to vary considerably. It is always advisable to set the pressure low to begin with, and to increase it gradually during printing until the correct setting is achieved. Printing with excessive pressure can result in the stone fracturing and is potentially dangerous.

Ink preparation

Successful, problem-free printing in lithography is largely dependent upon using good quality printing inks that have been specifically developed for hand lithography. Avoid using inks that are designed for the offset litho business, since these inks tend to be excessively greasy, soft and fast drying.

In the last 30 or 40 years, several companies worldwide have developed excellent ranges of both black and colour inks for this purpose; they include amongst many others, American based firms Graphic Chemical Company and Handschy Ink Company, the French firm Charbonnel and the UK firm Yorkshire Printmakers.

Proofing in black requires reasonably stiff, tacky non-drying ink. Whilst it is feasible to print with roll-up black, this type of ink tends to be very greasy and will cause filling in to occur during printing. Graphic Chemical Company's *Senefelder's Crayon Black* is extremely stiff black ink that is sometimes used on its own to print images with finely reticulated washes that would readily fill in if ordinary printing black was used, or when the weather is particularly warm. For proofing purposes, this ink is usually mixed with other softer printing black inks such as GCC's *Black 1796*, Charbonnel's *Crayon* or *Dessin* or Yorkshire Printmakers' *Non-Drying Strong Black*.

To prepare ink for printing:

1. Mix 1 part Senefelder's Crayon Black with 1 part printing black, mixing this well with a stiff palette knife at one side of the inking slab. Not very much ink is required for proofing, and a tablespoonful will probably be sufficient for most uses.

2. Lay a strip of ink out on to the inking slab, about the same width as the leather roller that is going to be used. Make sure that the leather roller has been well scraped back and is not contaminated with roll-up ink (see Glossary 'Rollers: conditioning and scraping back'). A composition roller, normally used for colour printing can be used for proofing if a leather roller is unavailable.

3. Roll the ink out into a thin, even film on the inking slab. As with rolling-up, it is better to commence inking with a lean ink film and to build this up during printing.

Printing

Having prepared paper and ink and having set up on the press, printing is relatively straightforward. In common with most professional workshops where printers are assisted by a 'sponger', it is ideal to work with a partner who can help keep the stone damp for you while you are busy inking and rolling. Certainly I have found it beneficial for students to work in pairs, since they provide each other with technical and moral support and printing is completed much more quickly.

For printing you will require the following:

* Gum arabic at 14° Baumé.

* Pure turpentine or lithotine.

* Liquid asphaltum.

* Rosin and French chalk.

* A supply of soft clean cotton or linen rags.

* A bucket or basin of cold clean water, two printer's sponges and a gum sponge trimmed to remove sharp or rough edges.

* Two pieces of clean, soft cheesecloth or fine muslin, each about 40in. (1m) square, gathered up into balls.

* A supply of fresh newsprint – sheets large enough to cover the whole stone.

* Prepared printing paper.

(a) Putting out ink on the inking slab.

(b) Pulling the ink out into an even strip.

(c) Starting to roll the ink out with a leather roller.

(d) Rolling the ink out into a thin, even film.

Washing-out the image and inking up

The procedure for printing is similar to that for rolling-up between etches. First, re-gum the stone by applying some pure gum arabic, spreading this evenly with a gum sponge and then buffing it down tight using some cheesecloth (as if polishing furniture). Re-gumming the stone in this way helps to freshen the gum coat on the stone and ensures that the image can be more easily washed out. Ensure that the gum coat is dry before continuing to the next stage. The image is once again washed out using turpentine or lithotine and a soft rag. Remove any excess turps and any resulting debris and then, with a fresh rag, apply some asphaltum. Ensure that the asphaltum is applied evenly without streaking, and buff this down until it is a light golden brown. Let the stone rest for a minute or two.

When ready to print, quickly wash the gum off the stone, using one of the printer's sponges. As with rolling-up, it is important to work quickly at this stage and not to allow water to settle on the asphaltum, for fear of water burn occurring.

Now use the other well wrung-out sponge to obtain a thin even film of moisture across the stone, then quickly apply ink to the image by giving about three swift rolls across the stone. It is most important to apply at least some ink to the image at this point, to ensure that the relatively fragile asphaltum image is not affected by water burn. As soon as a bloom of ink has been achieved, the image can then be inked at a slower pace.

Rolling patterns

Adopting a consistent and methodical rolling pattern is important during printing, to ensure that all parts of the image are inked equally and that inking remains consistent from one print to the next. Every printer will have his or her way of working, but I have found the following technique to work well:

1. Depending upon the image and the size of the stone, a *set* of about three to six rolls across the stone should be possible before the roller will need to be recharged with ink and the stone re-dampened with water.

2. The initial set of rolls across either the width or length of the stone should then be followed by a *fanning* pattern of rolling, with each set of rolls starting from a different corner of the stone. This helps to maintain consistency of inking and also helps you to remember how much ink is applied every time a print is made.

3. A final set of rolls across the width of the stone should then be adequate for inking the stone.

Following this pattern would therefore entail six sets of rolls:

Set 1 Across the width and/or the length of the stone.
Set 2 Fanning from the bottom-left corner of the stone.
Set 3 Fanning from the bottom-right corner of the stone.
Set 4 Fanning from the top-left corner of the stone.
Set 5 Fanning from the top-right corner of the stone.
Set 6 Across the width and/or the length of the stone.

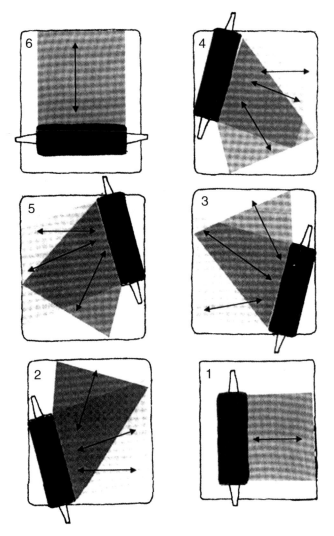

Typical rolling pattern used when printing black, and inking with a leather roller, involving six sets of rolls. In the first set the roller is used across the length of the stone; then four sets are started from each corner of the stone; finally a set is made across the width of the stone.

This method appears to work well for most images. Obviously it is important to keep the stone damp at all times, avoiding 'dry-roll' and to ensure that the stone is not overinked. The stone will need to be inked in this way every time a print is taken, and ink will probably need to be added to the inking slab periodically.

(a) Washing out the image with pure turpentine.

(b) Beginning to wash the image out with a clean rag.

(c) Using some more turpentine to totally remove the image.

(d) Applying some asphaltum to the stone.

(e) Buffing the asphaltum down with a clean rag.

(f) Starting to roll up the stone, rolling across the length of the stone.

(g) Rolling across the width of the stone.

(h) Sponging the stone between passes.

(i) Rolling-up across the diagonal of the stone.

Proofing on to newsprint and printing paper

Normally about two to three proofs are taken on to newsprint before advancing to quality printing paper. This provides the opportunity to achieve the correct inking level and the optimum pressure for printing. With the stone inked, ensure that the stone is carefully sponged after the final set of rolls has been applied. It is particularly important to avoid excess moisture and streaking at this stage, since unwanted watermarks can easily transfer to the print and in some cases can become permanently 'etched' in to the image on the stone.

To print the image:

1. Place a sheet of clean newsprint over the inked image and then cover this with another sheet on top.

2. Now place the tympan carefully on top, with the greasy side face up. Axle grease is used on the tympan to enable the stone to actually travel beneath the scraper bar under pressure. If insufficient grease is present, add some more.

3. Manoeuvre the bed and stone to the start position, as indicated by either the magnetic marker on a motorised press, or by tape marks set on a manual one.

4. Engage the pressure lever and crank the stone through the press until the stop marker is reached.

5. Release the pressure again and return the stone and bed to the inking position. Lift the tympan and set it to one side and then gently pull the newsprint from the stone.

6. As soon as a print is taken from the stone, it should be immediately sponged and inked with one set of rolls, to help 'pull the image back out of the stone'.

The initial print from the stone will probably be quite light. Further inking, adding more ink to the slab and increasing the pressure slightly, will however remedy this such that by the time the second or third print is taken, the stone should be inked to optimum level and pressure set correctly.

Printing onto quality printing paper

When printing on to a good sheet of printing paper, it is important to remember to place the paper on the stone in register.

Holding the paper in both hands, first match up the T-marks, and hold this edge in position on the stone with the index finger of your right hand. Then carefully lower the bar-end of the paper, matching marks on the stone and on paper. Cover the paper and the stone with one fresh sheet of newsprint, place the tympan on top and print as before.

As each print is pulled from the stone, check each print to make sure that the image has been fully inked; compare prints to ensure that nothing is filling in or disappearing!

Printing an acetate or mylar

Having printed a couple of proofs on to good printing paper, it is a good idea at this stage to print one image on to acetate or mylar, which can then be used to help trace the image in register onto other stones or plates. These can then be drawn up for printing colour runs.

When printing an acetate, ink the stone as normal. Sponge the stone as usual after inking, but then fan it dry using either a hair dryer or a *flag*. Since acetate is a hard, non-absorbent surface, the presence of any moisture on the stone would diminish the quality of the resulting print.

Use a sheet of acetate or mylar that will comfortably cover the whole of the stone and place a single sheet of newsprint on top. Print in the normal manner.

Before the acetate is removed from the stone, it is important to remember to trace the T-bar marks from the stone onto the acetate, using a fine permanent pen. Finally, the printed acetate can be dusted with French chalk, which will dry off the ink more quickly.

Closing and clearing up

Closing the stone is the term used to describe the process of inking and *tight gumming* that occurs when printing has been completed, particularly if the stone is to be stored for printing the image again in the future. Although the image will have been proofed at this stage, it is likely that the image will be editioned later, perhaps as a colour key image overprinting other colour runs. To close the stone, the image should be inked up fully in the normal manner, fan dried and then dusted with French chalk before gum arabic is applied and buffed down tight with clean cheesecloth.

Lastly, the stone should be removed from the press, covered with some paper and stored in racks or on a bench. Sponges and cheesecloths need to be rinsed and the latter well wrung out and hung up to dry. The inking slab should be cleaned up and the leather roller returned to its stand. Never attempt to clean the leather roller with any solvent, except in exceptional circumstances.

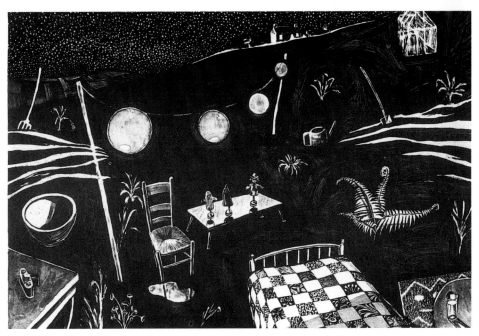

Night Garden, David Dubose, USA. 22.4 x 30.4in. (560 x 760mm), 1998.
A lithograph using crayon and tusche, printed at the Seacourt Print Workshop,
Bangor, Northern Ireland.

Just Testing, Judith MacLachlan, UK.
10.4 x 14.4in. (260 x 360mm), 1996.
Lithograph employing tusche
and scratching.

Cash in Hand, Caroline Wendling,
France. 13.2 x 14.4in. (330 x 360mm),
1996. A black-and-white lithograph
printed to show the full extent and
shape of the stone.

Welcome Home Yankee Doodle, Brian Kelly, USA. 16.4 x 20.4in. (410 x 510mm), 1996. A black-and-white proof of a print drawn using crayon, tusche, scraping and including texture transfer. The image was finally editioned in colour using five stones; a colour version of this image can be seen below.

Welcome Home Yankee Doodle, Brian Kelly, USA. 16.4 x 20.4in. (410 x 510mm), 1996. A five-run lithograph drawn using crayon, tusche and texture transfer.

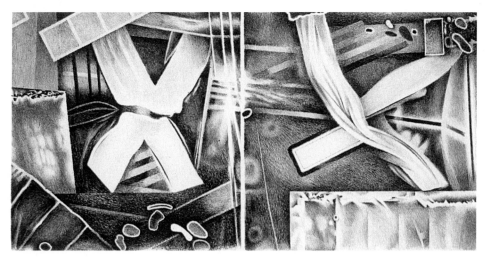

Extension, Clinton Adams, USA. 16.4 x 25.6in. (410 x 640mm), 1994.
A two-run black-and-white lithograph drawn using crayon. The image was first printed on to natural *Sekishu* paper then adhered to a sheet of Somerset Satin White. Printed by Sacha Wellborn at the Tamarind Institute. Clinton Adams was Director of the Tamarind Institute in Albuquerque 1970–1985.

Mechi, Caroline Thorington, USA. 26.8 x 19.2in. (670 x 480mm), 1997. Black-and-white lithograph using tusche wash, crayon and scraping with a razor blade.

Low Tide II, Sigrid Quemby, UK. 18 x 14.4in. (450 x 360mm), 2000. A two-run black-and-white lithograph and intaglio print. The lithograph was developed with crayon and tusche and then heavily scraped and honed. The etching was overprinted using a different colour of black.

Faux (Roung), Atin Basak, India. 24.4 x 22.4in. (610 x 560mm), 1998.
A four-run lithograph printed from a single stone. After each run had been printed,
the stone was lightly re-grained, treated with a phosphoric acid etch and then
redrawn using crayon and tusche and inking with a small roller.

Chapter 6

PRINTING IN COLOUR FROM STONE AND USING *CHINE COLLÉ*

 Printing images in colour

Whilst printing in black can be most fulfilling, most artists will of course aim to develop and print images in colour. A strong tradition of colour lithography developed from the early 19th century, starting with initial trials by Senefelder who, by 1816 had developed the means of printing multicolour images on to calico, using a series of stones to print each colour in succession.

The earliest colour lithographs made by artists appear to have used a chiaroscuro method similar to that used in early European colour wood-cuts. In this technique, one stone is used to print an underlying tint whilst a second stone prints the drawing on top.

Subsequent progress by the printers Godfrey Engelmann and Charles Hullmandel led to the development of chromolithography by the mid-1830s, which effectively surpassed all other previous methods of colour reproduction. However, colour printing at this time was mainly of a reproductive nature and it was not until the 'Golden Era' of lithography in Paris, from about 1880 until 1900, that there was a more creative use of colour by artists such as Toulouse-Lautrec, Vuillard, Signac and Bonnard. Influence from Japanese prints, and concepts of colour mixing and optical mixing as developed by the Impressionists and Pointillists, also greatly influenced colour printing at this time.

Throughout the 20th century, technical advances in ink manufacture and the increasing use of lithography plates and photoplate, helped in the continued development of colour printing. Nowadays, substantial printing of colour is carried out using both lightweight zinc and aluminium plates, as these are easily drawn and allow for rapid colour proofing. Plates are, however, quite often used in conjunction with stone, and many artists still prefer to print exclusively from stone.

Approaches to colour printing

Not surprisingly, there are many different approaches to colour printing that involve printing either from stone or from plate, or using a combination of the two. Some artists have also used a mixed-media approach, combining lithography with other print media such as screen printing, relief printing or etching. Another possibility for introducing colour comes through the use of chine collé and collage. For those artists who have access only to stone lithography, however, three main approaches can be considered for printing colour – the *multiple stone method*, the *reduction technique* and the *additive approach*, using a single stone.

Multiple stone printing

In the first technique, a series of stones of similar size will be required, whereby each stone is used to print a separate colour, with the final key image normally being printed last. In this procedure, the key image is usually drawn up first and the image processed and proofed, initially in black. The image is then printed onto acetate or mylar, so that the key elements of the design can then be traced in register onto subsequent stones for printing colour. In any use of multiple stone printing, it is of course essential to employ accurate registration marks and these should be transferred carefully from the *keystone* to each of the other stones, using the printed acetate.

When drawing the image it is most important that the artist takes account of the intensity of the colour that is to be printed. The intensity and *colour stretch* of an ink – its ability to print a range of tone – can vary considerably. Where colours such as black or blue can print a full range of tone from light through to dark, colours such as yellow print a much shorter range of tone, and consequently the image drawn on the stone must be drawn with considerable strength.

While any number of stones could conceivably be used to print the image, most artists tend to limit themselves to using between two and maybe five stones in any one print.

The use of just two stones enables the image to make use of a *tinting colour* such as in the print *Girl with a Cat*, 1931 by Clarke Hulton (see opposite), where a tint stone has been used to add subtle colour in the girl's hair and in the cat.

A more astute use of stone can exploit the four-colour process used in commercial printing, as seen in the print *Constantly*, by American artist Catherine Chauvin (p. 134). In this *acid-tint* image, secondary colours result when the relatively transparent primary colours overprint each other creating a rich and vibrant image.

The advantage of multiple stone printing is the ability to *colour trial proof* an image, by which various different colours can be printed and

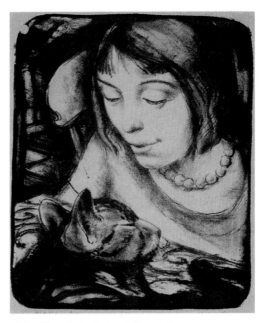

Polystep, Don Furst, USA, 6 x 4.6in. (150 x 115mm)
A three-run 'chiaroscuro' lithograph. Three stones were used to print first a pale blue-green, second a darker blue-green, and a blue-grey for the final

Girl with a Cat, Clarke Hulton, UK. 10.2 x 5.2in. (130 x 256mm), 1931.
A two-run lithograph that employs a 'tint stone' to print areas of ochre. The key image has then been overprinted in black.

Sea at Murlough, John Breakey, Ireland. 20 x 26.4in. (500 x 660mm), 1997.
A four-run lithograph printed in yellow, Indian red, blue and cream. The image was drawn using a strong tusche solution to achieve a painterly effect rather than a reticulated wash.

Boat Mobile, Paul Croft, UK.
10.4 x 15.2in. (260 x 380mm), 1991.
Colour lithograph printed mainly from
a single stone using a reduction
technique. A second stone containing
tusche wash and crayon drawing was
then overprinted.

Nuestra Señora de Rosario, Victor
Goler, USA. 15.2 x 12.2 (380 x 305mm),
1996. An eight-colour lithograph
printed using six runs and a blend. The
key image was drawn on stone using
crayon. Colour runs drawn on
aluminium plate using tusche.

A Foreign Place, Andrew Bird, UK. 18.4 x 29.4in. (460 x 610mm), 1998.
A twelve-colour lithograph drawn using crayon, tusche and rubbing crayon. Printed
from a single stone, re-grained after each run was printed.

Linda Quidi Vidi, Manuel Lau, Peru. 22.4 x 30.4. (560 x 760mm), 1999. Printed at Malaspina Printmaker's Society, Vancouver.
A five-run lithograph incorporating two rainbow rolls and split rolls where certain areas of the stone are inked with small brayers using different colours. Printed from a single stone and drawn with a variety of crayons, solvent tusche and shop black. Additions and deletions made after each run was printed.

Blood, Sweat, Gravy and Egg, John McNaught, UK.
9.2 x 12.4in. (230 x 310mm), 1994. A six-colour lithograph incorporating stone lithography printed in grey, reduction linocut printed in orange, pink, red and maroon, and a cross-section of Scots Pine printed in ochre.

tested from each of the stones being used. Colour trial proofing can also involve changing the order of printing of stones so that, in a three-run print for example, it may be discovered through proofing that the third stone may in fact be better printed as the first. Colour trial proofing thus allows for the optimum image to be obtained, and ensures that correct colour mixing and the correct order of printing is achieved in a small number of proofs, before the final edition is printed.

The Reduction technique of printing

For many artists, having access to numerous stones or plates would be considered a luxury and they must therefore find ways of printing from a single stone. A commonly used method is the *reduction technique* that shares similarities to the waste block process used in lino cutting, and is basically an extension of the manière noire technique used in lithography (See Chapter Eight).

In this process, a greasy flat is first established on the stone, using either strong tusche or *Shop Black* in order to print – usually a relatively light colour as the first run. Erasing tools and abrasives such as hones, caustic sticks, blades, drypoint needles, sandpaper, etc. are then used to create the second run of the image by 'drawing' into the flat – removing all those areas of the image that are to remain the first colour. A substantial first and second etch of about 10 drops is normally required every time deletions are made, to ensure that the deleted areas of the image remain open and do not fill in during printing of the second and subsequent runs.

This process of continuously deleting areas can be used until none of the original flat remains on the stone. Providing accurate registration is used, quite a number of runs can be built up to develop a multicolour print.

The resulting image is largely dependent upon the textures and marks made by erasing, and colours tend to print flatly like lino. However, a second stone or indeed the same stone freshly grained can then be used to print a key image on top. This can be drawn in a positive manner, making use of crayon and tusche which, when printed, will then appear vibrant seen overlying the previously printed colours.

The main disadvantage of this process is the inability to colour trial proof the image. As with waste block lino printing, the image must be editioned, starting with the first colour run and subsequently as the image is developed on the stone. Inevitably errors in drawing, use of colour and printing will occur, and it is therefore advisable always to print more proofs than is required.

The additive approach

A similar approach, again using a single stone, is the *additive technique* wherein the stone is either counter-etched or re-grained after each colour

run has been printed. American born lithographer David Dubose is an advocate of this method since it allows him to work freely and in an unplanned, spontaneous manner.

In this process, an initial drawing is made on the stone which is then printed in a light colour. For the second and ensuing colour runs, the stone can either be counter-etched – allowing for additional drawing – or, alternatively, the stone can be re-grained to allow for a freshly drawn run to be made. When the latter method is employed, it is important to print an acetate of the first run before the stone is re-grained, as this will help in registration.

Providing that accurate registration is once again used, this process of adding drawing, and indeed deleting areas, can be used to build up a substantial image in colour, such as in *Spinner* by David Dubose (see below).

As with the reduction technique, the edition of the print must be made as the image is developed, and it is again advisable to print additional proofs to allow for mistakes that inevitably will occur.

Spinner, David Dubose, USA. 16.4 x 20.4in. (410 x 510mm), 1995.
Colour lithograph drawn using crayon, tusche and rubbing crayon. The image was printed from a single stone, re-grained after each run was printed.

Multi media approaches

For some artists, working solely in a single medium such as lithography may be restrictive, whereas a mixed-media approach will offer an exciting means not only for developing colour, but also for providing textural, collaged and even sculptural possibilities. Mixed media will obviously mean different things to different artists and as a consequence a wide range of printed images can result.

In terms of printmaking, lithography has often been combined with all of the other major processes such as etching, woodcut, linocut, screen-printing, monotype and even photography. Prints have also been hand coloured using colour pencils, gouache and watercolour, collaged, and combined with chine collé. Lithographs have also managed to incorporate found objects and materials, such as the peat moss used by New York artist Roberto Juarez. Lithographs have also been printed on to a variety of surfaces including paper, cardboard, metal and perspex, and have been cut and reassembled in numerous ways to create statements in three dimensions.

Colour inks and modifiers

Successful colour printing is largely dependent upon the choice and correct use of appropriate inks, specifically designed and produced for the sole purpose of hand lithography. In every case, the use of commercial offset inks should most definitely be avoided for printing from stone and even for printing plates by hand. These inks tend to be very greasy and soft and will quite readily and rapidly fill in any image that has been drawn on the stone, causing substantial scumming on plate.

As with black ink, several companies worldwide, including Handschy, Graphic Chemical Company and Daniel Smith in the USA, and Yorkshire Printmakers in the UK, produce excellent ranges of colour inks that can be used for printing from stone.

Properties of colour inks

Good inks used for lithography will generally have good *body* or consistency, enabling the ink to be rolled out evenly, and *tack* or stickiness to enable the ink to adhere to the image on the stone. Pigments obviously need to be strong and enduring, stable and *non-fugitive* – resistant to ultraviolet light. True earth colours cannot be used since these pigments are too abrasive and will damage the surface of stone and also that of plate. Although oil-based, ink must not be excessively greasy, as this would cause non-image areas to ink up. Ideally, inks should be capable of printing the strongest of flats and the most delicate of washes and be capable of drying within a reasonable period of time.

Most commercially produced inks are therefore highly engineered to meet all of the above criteria. Inks are normally made up of pigments and binding agents suspended in a suitable vehicle consisting of linseed oil or resin or alkyd varnishes, or in varying combinations of all three, enabling the pigment to be transported and fixed onto the paper. Binding agents are usually varnishes added to alter the viscosity of the inks, whilst bodying agents such as magnesium carbonate are inert materials added to give the ink bulk and a good working consistency.

Inks are produced in a wide range of colours and can easily be mixed to obtain whatever hue is required. Most colours tend to be relatively transparent, and very few pigmented colours – with the exception of black, opaque white and chrome yellow – are opaque enough to completely cover underlying printing.

Transparency is obviously a useful property, since overprinting allows for secondary colours to develop, providing for a more economical use of colour and fewer runs. The transparency of colours can also be increased by using an *extender base*, a transparent medium that can be mixed in varying proportions to the ink.

Unlike black ink, colour inks tend to be faster drying, less tacky and softer in consistency and therefore need to be *modified* and printed with greater control. *Modifiers* are a number of different materials that can be added to colour inks during printing, to alter either the body or the tack of the ink being used. Normally only some of the ink will be modified at any one time, since conditions may either change during printing or it may be found that the ink has been overly modified and requires to be mixed again with some of the original stock.

Magnesium carbonate and varnishes

Generally, most colour inks used straight from the can are far too soft for printing and, used in this way, will cause scumming and filling in to occur. *Magnesium carbonate*, an inert 'fluffy' white powder that is used by most lithographers to improve the body of colour inks, is a useful modifier that makes the ink much more stable for printing.

Addition of magnesium carbonate effectively helps to stiffen the inks and ensures that the ink does not spread to the negative parts of the image. Depending upon the initial consistency of the ink, about one teaspoonful of magnesium is added to a 'tablespoonful' of ink; well mixed, the ink should take on a slightly 'stringy' appearance.

Excessive use of this powder can, however, cause problems of rolling out an even ink film, and since magnesium absorbs water, can cause the ink to become waterlogged and to *flocculate* wherein the ink begins to disintegrate and a loss of colour ensues. To counter this, *varnishes* are sometimes used as a modifier, added to the ink so that less magnesium is required.

Das Element Luft,
Dagmar Mezricky, Austria.
33.6 x 24.8in. (840 x 620mm),
1990. A ten-run lithograph
that makes good use of
rainbow rolls. Printed
from a single stone by
Hanke Ernst.

*The Simple Foregoing
Rules*, William Fisher,
USA. 30.4 x 22.4in. (760 x
560mm), 1995.
Mixed-media print
utilising screenprint,
lithography and
embossing from an
etching plate.

Litho varnishes are produced in a range from weak through to heavy and in the USA are rated from #00 to #8. Weaker varnishes tend to be very greasy and can increase the tendency for scumming and tinting to occur, whilst heavier varnishes can effectively seal the paper, resulting in a permanent sheen.

A weaker varnish such as Graphic Chemical Company No. 3 is often used to increase the tack and to soften the ink whenever large flats of colour are being printed, or possibly whenever problems are encountered in printing a faintly drawn image. A stiffer varnish such as Graphic Chemical Company No. 8, however, would be used in combination with magnesium to increase the body of the ink, sufficiently stiffening it to provide an ideal consistency for printing. Whichever varnish is used, no more than one part varnish to four parts ink should ever be mixed.

Setswell and driers

Other modifiers sometimes used include an American product called *Setswell*, which is similar to petroleum jelly or Vaseline. A 'pinch' of this compound slows down the drying time of the ink and appears to help the ink penetrate the fibres of the paper, allowing each layer printed, to 'sit comfortably' on top of each other. Conversely, *cobalt driers* are sometimes added to the ink to speed up the drying time on occasions when ink is being printed on to a non-porous surface. Only minute quantities of driers should ever be mixed into the ink, if needed at all, and in most cases its use should be avoided altogether.

Whatever colours are being used for printing, it is usually a good idea to mix all the colours that are going to be needed prior to proofing, and to store these in airtight envelopes of acetate or foil. It is also a good idea to get into the habit of making notes on how each colour has been mixed, and to carefully label stocks of mixed colours. Modifiers should never be added to the inks until you are ready to start printing.

Use and control of colour inks during printing

For some printers, colour lithography can throw up all sorts of problems ranging from the image filling in on the stone to the other extreme where images mysteriously disappear during printing. Many other common afflictions such as lap marks, scumming, 'push', wet and dry rejection, saltiness and ghosting can be enough to persuade any artist to work in black and white. Yet many of these problems often result from an inexperienced handling of ink, and in the way the rollers are used on the stone.

Rollers used for colour printing

The choice of roller used for printing is certainly an important consideration. Whilst leather rollers, first made commercially in 1803, were

widely used for colour printing, this practice rarely occurs today, as a whole set of customised rollers would be required. Nowadays all colour printing is done using either a composition roller made of glue and glycerine, or using rollers made from rubber or polyurethane.

Polyurethane rollers are useful as they have a chemical durability and are resistant to abrasion, whilst the material itself has a natural tack that serves to pick up and deposit ink effectively in a thin, even film.

Rollers are manufactured to varying degrees of hardness, described as the *durometer* in the USA and as the *shore* in the UK. Normally rollers of 35 durometer or 30 shore are required for lithography.

Ideally, the roller being used should be large enough, both in terms of width and in circumference, to ink the whole surface of the stone without lapping. If this is not possible, then a smaller roller can be used, but quite often roller marks will result – especially when printing very transparent colours.

Rolling out ink

As with printing in black, preparation prior to printing is most important. Ensure that the stone is set up correctly on the press, paper is torn to size and that you have all the necessary materials and solvents to hand. It is also a good idea to mix up suitable quantities of all the colours that you think will be needed during the proofing session, and to mix in modifiers well just before printing begins. The ink should then be rolled out in to a thin, even ink film on a clean, level inking slab, using a clean roller. It is most important that a lean ink film is used, since overinking with a heavy deposit of ink will most certainly cause filling in and scumming to occur.

In order to avoid lap and roller marks developing, ensure that the roller is rotated through one quarter turn after every time that a pass is used to roll the ink out on the slab. *Tracking*, ensuring that the roller rolls over the slab and on the stone in a constant manner without deviating at an angle will also help to avoid roller marks occurring.

Washing out, rubbing up and inking the stone

As normal, first re-gum the stone, buffing the gum coat down tight using soft cheesecloth, and ensure that this has dried before washing out the image using turpentine. Instead of using asphaltum, apply some of the colour ink diluted with a little turps, by *rubbing up* the image with a soft rag. Ensure that this ink is applied to the whole of the image and is buffed down evenly, just as asphaltum would have been applied. Finally wash off the gum coat with a damp sponge and begin to ink the stone, using the roller in a gentle fashion.

Normally fewer sets of rolls are required when printing in colour; depending upon the size of the stone, about four sets of rolls should be sufficient for initial inking. As with printing in black, it is important to ink

the stone from different directions, but a fanning pattern should be avoided, and tracking should be kept consistent to avoid roller marks from appearing. It is a good idea then to complete alternate sets of rolls across the stone, with the first set inking across the width and the next along the length and so on.

As usual, the first couple of prints are normally taken on to newsprint to ensure that the correct inking level and pressure are obtained, after which printing onto good printing paper can take place. If an edition is being printed, it should be remembered that additional ink will need to be added to the slab periodically.

Changing colours and colour trial proofing

Depending upon the number of runs being used, normally about a half a dozen colour trial proofs would be taken on to quality paper, perhaps using a variety of different types of papers, and involving changing colour a number of times. The aim of colour trial proofing is to achieve the correct colour balance and order of printing for the edition, by first printing a limited number of proofs. It is common, therefore, to change colour during proofing and for a couple of proofs to be taken, first in one colour and to then ink the same stone again in a second colour. When it is known that a number of colours will be used in this way, it is advisable to start proofing using the lightest colour first. Changing colour is then relatively easy and quick, using a 'loose gumming technique' as follows:

1. Having printed the final proof with the first colour, ink the stone with about two or three sets using this colour.

2. Loose gum the stone by applying gum arabic with a small gum sponge, spreading the gum evenly across the whole surface. Do not use French chalk. Fan the gum coat dry.

3. Scrape back the ink from the slab and clean this and the roller using white spirit or isopar. Roll out the new colour in to a thin, even film on the slab.

4. Now wash off the gum coat and proceed to 'strip' off the old ink from the stone by printing on to fresh newsprint. Repeat this using a second sheet of newsprint.

5. Now proceed to ink the stone using the second colour. At least one print onto newsprint should be taken before using a quality printing paper.

Whenever a change of running order is contemplated, this loose gumming technique can also be used to keep the stone 'open' while another stone is being proofed – avoiding the need for the stone to be closed in black until printing is completed. A stone can usually be kept under loose gum in this way for up to 24 hours.

Do not feed America to the Indian, which is a tribalizing and not an Americanizing process, but feed the Indian to America, and America will do the assimilating and annihilate the problem. Brig. Gen. R.H. Pratt The Indian Industrial School Carlisle. Pa. 1908

Colonial Colours, Lynne Allen, USA. 30.4 x 67.2in. (760 x 1680mm), 1997
A multi-media triptych. The left panel was printed from stone, the right panel from plate, and the middle section was screenprinted. The image was composed using a combination of tusche and photocopy transfers.

Spellbound Series: Cabalitto Blanco, Elspeth Lamb, UK, 30.4 x 22.4in. (760 x 560mm).
A multicolour lithograph printed on to black Arches paper. As well as being noted for her use of reticulated tusche washes, Elspeth also likes to use metallic powders that are sometimes mixed in with the inks, or are dusted over the print while the image is still wet. The excess powder is then airbrushed away once the ink has dried.

Opposite page:
Hochzeitsblatt, Hanke Ernst, Switzerland, 2000.
A ten-run lithograph by the artist and Master Printer Ernst. All the colours were printed from a single stone.

Salix I, David Jarvis, UK.
24.4 x 19.2in. (610 x 480mm), 1998.
A twelve-colour lithograph printed to
show the full extent and shape of the
stone, re-grained after each run was
printed.

Paul, Paul Wunderlich, Germany. 37.8 x 27.6in.
(945 x 690mm), 1998.
A seven-run lithograph printed by Hanke Ernst from
a single stone. The image was first developed on
transfer paper using crayon and tusche, then
transferred to the stone. The image on the stone
received further deletions and additions as each
colour was printed.

During colour trial proofing it should be possible to print at least four or five colours on top of each other, allowing for a rapid development of the image. This is only possible however if the print is dusted with magnesium carbonate after each colour has been proofed. The magnesium basically dries the surface of the ink on the paper sufficiently to allow the next colour to be printed. The magnesium should be applied evenly to all of the image using a large soft clean brush. Although the magnesium may appear to dull the image, it is usually dissolved by the moisture on the stone as the next colour is printed.

Closing the stone in black

Once printing has been completed, it is most important that the stone is closed by re-inking the image in a non-drying black. To do this, strip the excess colour ink from the stone and then ink it directly with black, using a leather roller. Close the stone by first dusting with French chalk and then applying gum arabic, which should be buffed down tight using clean, soft cheesecloth.

Troubleshooting some common problems in colour printing

Problems that occur during printing are easily solved providing that you are vigilant and become aware of the problem from the onset, and resolution is carried out in a methodical and cool-headed manner. Some of the most common problems and possible solutions are outlined below:

Saltiness

Saltiness refers to a dry looking, less than fully inked image on the paper and is characterised by flecks of bare paper seen through the ink, particularly noticeable on large areas of printed flats. The problem can be due to underinking and may be solved by using an extra set of passes on the stone or by adding extra ink to the slab. Alternatively, saltiness can result from too little pressure, solved by slightly increasing the pressure.

Filling in

Filling in occurs when ink spreads to negative areas of the image, characterised by loss of definition, reticulated washes becoming solid, and an overall heaviness. The problem can develop gradually, without being noticed, or it can occur suddenly, usually after too much ink has been added to the slab.

Filling in is often a problem of overinking, or develops from using an ink that is far too soft. Initially use less ink, strip ink from the stone, scrape back the inking slab and use fewer passes.

If the problem persists, the ink needs to be modified using either magnesium carbonate or a stiff varnish. Roll out the freshly modified ink, wet wash the stone to remove the old colour and continue to ink, using the newly modified ink. If the problem still persists it may be possible that excess pressure is being used, or possibly the image was under-etched and requires a third etch. In the latter scenario, wet wash the image and roll up in a stiff black ink such as Senefelder's crayon black and then re-etch the image. Allow the stone to rest again before printing colour.

Loss of image

Gradual *loss of image* may occur as progressive proofs are taken from the stone, and is likely to be a result of under-inking or lack of pressure. In most cases the problem is easily remedied by adding more ink to the inking slab, giving extra passes on the stone and adjusting the pressure. Using the roller more gently on the stone will also allow for more ink to be deposited.

Loss of image can also be attributed to insufficient grease content in the printing ink and this can be resolved by adding a little No. 3 or medium litho varnish. Ink that has had magnesium added will also absorb water during printing and will eventually become waterlogged. In severe cases *flocculation* will occur, exemplified by the ink breaking down, leaving small shards across the surface of the stone. Waterlogged ink is unable to adhere effectively to the image on the stone and the resulting print is underinked. It is important, therefore, to habitually scrape back the inking slab after every five or six prints, removing some of the ink and replacing it with fresh stock.

Ghosting

Ghosting is typified by a light halo effect developing at the edges of the image and is usually most noticeable at the margins of large flats. It is a problem that can eventually lead to image loss in these areas and it is often caused by using the roller continuously from a single direction. It can also develop from poor tracking, where the roller deviates at an angle as it is rolled across the stone. It is most important therefore to start each set of rolls across the stone from a different point, and to ensure that in each pass, tracking remains consistent and the roller does not deviate as it is rolled back and forth.

Push

Push is a common affliction that is not always recognised by printers. It is a somewhat ugly 'pillowy', or mottled, texture that is seen most conspicuously within large printed flats but can also become apparent in areas of crayon and wash. A number of factors can contribute to the development of push, including overinking, too soft an ink being used, too much

pressure, the paper itself stretching during printing and the paper gliding across the stone under pressure.

When severe problems of push occur, it is a good idea to try eliminating the possible factors one at a time. Thus first try using less ink, then less pressure and then perhaps stiffen the ink by adding magnesium. It is also a good idea to calender the paper prior to printing, as this will avoid problems of paper stretch and will also ensure more accurate registration.

A favoured solution by many printers is to hold the tympan up at an angle as the bed is run through the press, since this seems to alleviate the problem of paper gliding across the stone. This is an easier task on a motorised press than on a manually driven one and in each case care should be taken to not trap your hand beneath the scraper bar!

Wet and dry rejection during overprinting

In editioning it would be normal to print one colour run a day since the ink must be 'touch-dry' before the next colour run is completed.

Wet rejection is characterised by bad definition and a mottled appearance, and occurs when the previous printed ink is too wet and is unable to accept the next layer. In severe cases it may not be possible to overprint at all and the previously printed layer may offset onto the stone, causing problems of scumming and filling in. In such cases it is best to wait until the print has dried further before printing again.

Dry rejection, meanwhile, will occur if the print has been allowed to dry too much and the overprinted ink is unable to merge successfully with the layer beneath.

Chine collé

Chine collé, also known as *papier collé*, is the term used to describe the process of collage, whereby thin sheets of paper are mounted in register onto a usually heavier substrate paper, generally to provide areas of localised colour in a design. Whereas in intaglio printing, the *chine collé* is commonly applied to the supporting paper at the time of printing, in lithography, *chine collé* papers are normally stuck down either before printing has occurred, or as a final print run completing the image.

Ideally, papers used for *chine collé* should be very thin, like some of the Japanese, Chinese or Indian silk tissues that are produced in varying subtle shades and also in bright colours. Once adhered to the supporting sheet and overprinted, their physical presence should be barely discernible, apart from their evident colour and texture –sometimes caused by fibres and other innate organic material. Supporting papers meanwhile should normally be the heavier printing papers commonly used, such as Rives BFK, Arches and Somerset.

Untitled, Suzanne McClelland, USA. 24 x 18in. (600 x 450mm), 1995.
One of a series of three lithographs developed wholly as *chine collé* by New York
artist McClelland. Each of the elements was drawn and printed from separate
stones and plates. Printing onto Japanese papers – *Kizukishi*, Mulberry, Cedar Gasen
and matt Mylar – each piece was then cut out and assembled and adhered to white
Inomachi Nacre paper. Printed by Frank Janzen at the Tamarind Institute.

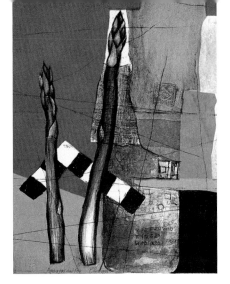

Loch Sunart, Gill Tyson, UK. 12.8 x 14in. (320 x 350mm), 1998. A four-colour print that incorporates stone lithography, screenprinting and *chine collé*. Image on stone was developed as a reductive *manière noire*, and *collé* using thin Japanese paper was added just before the final run.

Asparagus and Fish, Paul Croft, UK. 11.6 x 8.8in. (290 x 220mm), 1999. A five-colour lithograph using *chine collé* cut envelopes, silver foil paper, and an inked Chinese stamp.

Sky Fan at the Bird Islands, Anne Meredith Barry, Canada. 16.4 x 22.4in. (410 x 560mm), 1992. A three-run lithograph incorporating Japanese paper *chine collé*. Printed by Barry and George Maslov at St Michael's Print Workshop, Newfoundland.

Chine collé is most successful when the qualities of the collage material are used effectively to enhance the main elements of the image that is to be printed. Selection of appropriate papers or materials should be based upon colour and texture and cut collage shapes, the need to reflect major compositional elements found in the image, as, for example, seen, in the print *Asparagus and Fish* by the author (see opposite), which makes use of Japanese papers and envelopes.

Gluing the *chine collé* in register

Chine collé necessarily requires that each piece of cut collage material be adhered to the supporting sheet in correct register. Glues used to stick the material ideally need to be enduring, and must also be acid-free and archival. Unfortunately, however, many glues tend to be quite acidic and would result in the discolouration of the paper, eventually leading to its disintegration. Although traditional rice paste glue could be employed, some of the new pressure sensitive acrylic polymer adhesives are excellent for *chine collé*.

Rholplex® N-580, produced by Rohm and Haas in the USA, and its UK equivalent Primal® E-1961, are excellent, since they have a high pH value of about pH 8.5. These adhesives are capable of being airbrushed onto the collage material, and will only stick permanently once pressure has been applied. A similar adhesive (WS1650) with a pH of 6 produced by Falkiner Fine Papers is also very good for *chine collé*.

To prepare paper and *chine collé* material:

1.	First prepare all of the cut pieces that are to be used as *chine collé* in advance. If an edition is being printed this cutting needs to be consistent, achievable through use of a thin metal template of the shape, cutting around this and cutting simultaneously through several layers of the thin tissue material using a sharp blade.

2.	The supporting sheets of paper should also be prepared in the normal manner – consistently torn to size with T-bar registration marks set on the reverse side.

3.	Adhesive should then be applied to the *reverse side* of each piece of *collé* that is being used. Pressure sensitive glues can normally be sprayed using an airbrush, providing a couple of drops of glycerine are added. Spray a few pieces of *collé* at a time, or as many as can be coped with, and allow the glue to dry until slightly tacky.

Sticking the material down in register is relatively simple:

1. Registration of the pieces of *collé* can be made by referring directly to the image drawn on the stone, providing that T-bar marks have been cut. Place a sheet of clean perspex or acetate over the drawn stone and fix this in position with tape.

2. Place a piece of the *chine collé*, glue side face-up on top of the perspex, and manoeuvre this in to the corresponding correct position in relation to the image on the stone.

3. Carefully lay a sheet of the supporting paper on top, ensuring that the T-bar marks are used to register this correctly. Applying light pressure to the back of the printing paper should be sufficient to fix the *chine collé* into position. Lifting the paper, the collaged piece can then be smoothed down on the front surface.

4. If pressure sensitive glue has been used, the *chine collé* needs to be well pressed down on to the supporting paper. This can be most effectively done by placing the paper between two sheets of newsprint, on top of a plate backer or large stone, and running this through the press under printing pressure.

Several layers of *chine collé* can be built up in this way creating a sophisticated collage on the supporting paper, prior to the image being printed from stone or plate.

Chapter 7

THE USE OF
TRANSFERS
ON STONE

 Transfer lithography

Transfer lithography refers to the process of developing an image on a secondary surface such as transfer paper, acetate or mylar, and then imprinting that image onto the surface of the stone by running it through the press under pressure. Once applied to the stone, the image can be further manipulated if desired, before being proofed and editioned in the usual manner.

Senefelder anticipated the use of transfer techniques in his treatise on lithography published in 1818. The use of transfer lithography was subsequently developed throughout the 19th century to print labels and posters, and later became integral to the development of photolithography. Partly as a result of its association with commercial printing, fine artists largely avoided transfer techniques until the latter part of the 19th and early 20th century. Nowadays, transfer lithography is seen as an important extension to the image making process.

There are many different approaches to transfer lithography and some artists have devised unusual techniques best suited to their own ways of working. Common to all transfer techniques, however, is the advantage of being able to develop an image without necessarily having to work directly upon a freshly grained stone. Some of the more commonly used techniques of transfer lithography that are discussed in this chapter include:

- Using specially gum-coated transfer paper.
- Monoprint transfers using transfer paper and acetate.
- Textured transfers using transfer ink.
- Photocopy transfers.

Gum transfer paper

Gum transfer paper is specially prepared paper coated with either gum arabic, or a water-soluble glue such as gelatine, or a starch-based paste containing flour. Most commercially available transfer papers are usually

quite thin and smooth, although textured varieties mimicking the surface of stone or plate can sometimes be obtained. However, it is relatively easy and more cost effective to make your own transfer paper that will work satisfactorily for most drawn images.

Drawings are first made on to the coated surface of the paper using lithographic crayons and solvent tusches. The paper is then placed face down onto the surface of the stone, dampened from the back to release the gum and the drawing, and finally run through the press under pressure to transfer the image to the stone.

Transfer paper is a useful method for those artists who are inhibited by the thought of drawing onto the surface of freshly grained stone. Drawings made onto paper that fails to satisfy the artist's ideal can easily be discarded and a new drawing made on another sheet; a similar drawing made directly onto the stone would obviously need to be removed by graining.

Treated as an ordinary sheet of paper, opportunity arises for the artist to draw within the privacy of his or her own studio away from the distractions found in the print workshop. Alternatively, the paper can be stretched onto a board and taken out 'on location', for drawing landscape, for example, in a more spontaneous fashion. A further advantage is that images are printed as originally conceived, since they are first reversed onto the stone through the transfer process and then reversed again during printing.

Transfer paper can also be exploited to include collage from a number of sources. As the paper is relatively thin, rubbings can easily be made from textured surfaces using soft litho crayons to create *frottage*. Elements from woodblocks, linocuts, typefaces, screenprinted images, monoprints and even images from other lithography stones or plates can be printed on to the transfer paper using particularly greasy transfer ink. The latter examples can provide opportunities for image reversal and this is described in the following chapter. (Prints from intaglio plates however are best transferred on to a non-coated transfer paper.) A good example of a print using an assemblage of transfers produced in this way is *Shepherd's Dream* by the artist Jonathan Jarvis (see opposite), who transferred inked woodcuts and corrugated card and then worked over these with crayon and tusche.

Most lithographic drawing materials and techniques can be used on transfer paper, with the exception of tusche washes that have been mixed with water. If these are applied, the gum coating on the paper is dissolved and the tusche is absorbed into the body of the paper. Tusches dissolved with solvents, such as turpentine, lithotine or white spirit can, however, be applied to good effect.

Broken Edge, Simon Burder, UK. 20 x 26in. (500 x 650mm), 1990. In this lithograph a rubbing taken from a piece of slate was transferred to the stone using gum transfer paper. Further drawing was added using crayon and tusche and by honing.

Shepherd's Dream, Jonathan Jarvis, UK, 15.2 x 22.4 (380 x 560mm).
In this black-and-white lithograph the image was made by inking various different materials, including corrugated board and wood grain and impressing these onto the stone. Other areas of inked woodcut were transferred using gum transfer paper. Further drawing was done using crayon, tusche and honing.

Finding Five, Rachel Gibson, UK. 12 x 16.4 (300 x 410mm), 2000.
In this lithograph a rubbing from a linocut was transferred to the stone using gum transfer paper. The print was hand coloured with watercolour and wax crayon resist.

Rosa Rugosa, Kurt Wisneski, USA. 19.2 x 16.4in. (480 x 410mm), 1988. A five-colour lithograph. The image was developed using photocopy transfer, carbon paper transfer, crayon and tusche. Acid tint employed on the 'rose', printed using blends of colours.

The Moth's Departure, Paula McIver Nottingham, UK. 12 x 15.2in. (300 x 380mm), 1999. Transfer lithograph by Nottingham, who makes her own gum transfer paper using 'hydrogum'. The image was drawn using solvent-based tusche and a medium crayon. Further additions and deletions were made on the stone after the image was proofed and counter-etched.

Making your own transfer paper

Transfer paper is very quickly and easily made, using a lightweight cartridge paper and gum arabic. A number of stout drawing boards and some brown gum tape are also required for stretching the paper.

Full size sheets of cartridge paper can be stretched, but ideally the paper should be cut down to the required size beforehand. Paper used for drawing on should be slightly larger than the intended image and smaller than the stone to be used.

To make up the transfer paper:

1. First soak the sheets of paper in a paper soak for at least 15 minutes.

2. Dampen the surface of the board being used and ensure that it is clean.

3. Lift a sheet of paper from the soak and allow the excess water to drain from it. Place it flat on the board and use a clean sponge for gently smoothing the paper out from the middle towards the edges, to remove any air pockets.

4. Use strips of gum tape to secure the edges of the paper. Blot the paper with some newsprint and allow it to air dry, with the board placed horizontally.

5. Using a small piece of sponge, apply gum arabic diluted 1 part to 1 part distilled water. Spread the gum evenly across the surface of the paper and then dry with a warm hair dryer.

6. Apply at least two additional coats of gum in the same way, ensuring that as even a surface as possible is built up. Once complete, the paper should have a reasonably smooth shiny surface.

Transferring the drawn image to stone

Once the drawing has been completed on the transfer paper, any areas of liquid drawing ink or solvent tusche should be allowed to dry; any elements that have been produced using transfer ink will probably remain slightly tacky. The image is now transferred to the stone under pressure, etched twice as normal and then printed. The transfer can be treated as an end in itself and printed as the finished image. However many artists prefer to use the process as a basis for further development. After the image has been rolled up in ink, the stone can be counter-etched and drawing added directly over the transfer. The image can also be one part of a series of runs that overprint each other.

To transfer the image to the stone use the following procedure:

1. Transfers should be made before any other drawing has occurred on the stone, with the exception of toner washes and photocopy transfers.

2. The freshly grained stone should be set up on the press as for printing, centred on the press bed and with the 'bar' end brought up against the spacers. A scraper bar, wider than the transfer paper but not as wide as the stone, should be installed. Set the 'start-stop' positions so that the scraper bar remains resting on the stone at the start and finish of the application.

3. Set the pressure on the press. *Very slight* pressure is required to transfer the image from paper to stone. This should be less than normal printing pressure which, if used, would cause the transfer paper to slide and rip.

4. Place the gum transfer paper face down on top of the stone and position it as required.

5. Holding the paper in position, use a damp sponge on the back to moisten it. There will be a tendency at first for the paper to start cockling; however, as the paper absorbs more moisture, it will begin to flatten out again. Avoid using excessive amounts of water and allow the paper to absorb moisture slowly. As the paper becomes damper it will start to adhere to the stone. Use the sponge to gently remove any air bubbles by smoothing out from the middle of the paper to the edges.

6. Once the paper is sufficiently damp, it will adhere to the stone totally flat. Cover the stone with two sheets of fresh newsprint, place the tympan on top and run through the press under pressure.

7. Disengage the pressure and return the press bed back to 'home' position. Remove the tympan and newsprint and then peel back one corner of the transfer to check upon progress. It may be necessary to run the stone through the press a couple of times to ensure that the transfer has been successful.

8. Once complete, carefully peel the transfer back from the stone. The gum arabic will have dissolved and the image will now be seen on the surface of the stone. Remove any fragments of torn paper and then fan the stone dry.

Processing transfer images
In transfer lithography, the image on the stone is comparably weaker than an image drawn directly. For most types of drawing, gum arabic is

sufficient for the first etch. However, those areas of the image that have been drawn using solvent tusche or heavily applied rubbing crayon will probably require a first etch of between 2 and 6 drops of nitric acid.

A certain amount of gum arabic released from the transfer paper will have already been deposited on to the surface of the stone. Ensure that this is dry and then apply rosin and French chalk and dust away the excess.

Apply the first etches in the normal manner, applying gum arabic to the whole surface of the stone and then any further strengths of etch if these are required. Remove any excess gum and buff the gum coat down tight using clean, soft cheesecloth.

The stone is washed out in the normal manner, asphaltum applied and the image rolled up using greasy roll-up black. As usual, the strengths for the second etch are dependent upon how the stone appears after inking.

It is not unusual for transfer images to ink up more heavily than expected, especially if solvent inks and tusches have been employed. In such cases, the second etch may need to be increased in strength to ensure that the image remains stable during printing.

Monoprint transfers

Monoprinting is a hugely versatile process that includes a broad range of techniques and approaches from purely autographic methods, to the use of intaglio, screenprinting, relief printing and lithography itself. More correctly termed as monotype, this form of printing has become increasingly popular since the 1960s and is now generally accepted by most galleries and collectors alike.

Monoprinting is sometimes used in lithography, to print a unique colour run underlying the key image printed from stone or plate. However, it is the potential for developing spontaneous autographic marks that is of relevance in transfer lithography. Monoprints used for transferring to the stone are normally made directly onto either transfer paper or acetate and then applied to the stone. Particularly greasy ink is required, and ideally transfer ink such as Charbonnel's *encre à la report or monter*, modified with 10% linseed oil, should be used.

Black line monoprinting

The simplest method of monoprinting is a linear technique first used by Paul Gauguin to create compositional sketches for painting. The process, similar to drawing through carbon paper, is capable of producing a distinctive quality of line that varies from being sharp and precise to soft and fuzzy.

For monoprinting, first roll out some greasy transfer ink or even roll-up black onto a sheet of glass or perspex. The ink needs to be rolled out in to a thin, even film and the area should be large enough to accommodate the

size of the image. The ink film is then blotted back a couple of times using fresh newsprint.

If using transfer paper, this then should be placed gum side face down on top of the ink; alternatively a sheet of acetate or even thin photocopy paper can be used. Simply by drawing on the reverse side with a sharp pencil or ballpoint pen the ink adheres to the front surface and the image is made.

The advantage of using acetate or thin photocopy paper is that the image can easily be transferred to the stone under pressure, without having to use water. The resulting image on the stone will, however, be very delicate indeed and should be etched using only gum.

Painted monoprints on acetate

For a more painterly approach, the image can be brushed or rolled directly onto acetate using Charbonnel *Noir à monter* – soft, greasy ink that can be thinned by adding about 10% linseed oil. Using brushes, rollers and rags the image is built up by painting, dabbing, wiping and scraping through the ink until the desired result is achieved. Washes can be made by thinning the ink with turpentine and adding linseed oil, although these may dry before the transfer can be completed. Care should be taken not to use too heavy an ink film which, under pressure, could spread to other parts of the image. Use gentle pressure and also allow the ink to dry until slightly tacky, before the transfer is made to the stone. The image is etched in the normal manner, using gum arabic and etches of between 2 and 6 drops if deemed necessary. A stronger second etch will probably be required.

Gouache resist monoprint on acetate

An interesting variation of monoprint transfers using gouache paint and transfer ink was introduced to me by the Argentinean artist Daniel Zelaya whilst working at the Tamarind Institute in 1995.

In this technique the image is first painted on to a sheet of acetate, perspex or lightly sanded linoleum, using gouache paint with a little liquid soap added, to help it to adhere more easily. Once dry, the image is rolled over with transfer ink, so that the whole image area is covered with an even and quite dense film of ink. Then, not unlike sugar lift in intaglio printmaking, the gouache is dissolved by submerging the ink-covered image in a basin of warm water, or by holding it underneath a running tap. The gouache image reappears from beneath the ink and is seen as a negative or white image against a black field. Further adjustments can be made by drawing through the ink before it is then transferred to the stone using the same pressure as for gum transfer paper.

Texture transfers using transfer ink

For many artists, it is desirable to incorporate a 'found' or 'multi-media' element to their work, using natural and manmade materials. In intaglio printmaking, for example, textured surfaces are impressed into soft ground, and in relief printing actual found objects can be inked and printed. In lithography, the transfer process is also used to introduce similar information to an image.

As in soft ground etching, the materials most suitable for transferring should be relatively flat and easily inked with a roller. Textured surfaces such as corrugated cardboard, heavily grained wood, leaves, feathers, cloth, clothing and embossed wallpaper, etc. are ideal and easily inked using a small brayer. Images from rubberstamps similarly inked with transfer ink might also be considered.

The inked materials can be pressed directly on to the surface of the stone by hand, but it is usually more effective to offset the image from a roller. Having first inked the material with transfer ink, another clean roller large enough in circumference to cover the whole extent of the inked area, is then passed over, picking up the image. The image is then offset onto the stone by running the roller carefully over the surface.

Photocopy transfers

In the late 1970s, the Tamarind Institute and Nik Semenoff working at the University of Saskatchewan researched into the use of toner and photocopy transfers. Since then the process has been eagerly adopted by workshops worldwide and in recent years has become increasingly popular. For those workshops without photoplate facilities this technique represents the only route available for introducing photographic imagery.

The photocopy transfer method makes use of solvent to transfer the toner from a black-and-white photocopy to the surface of the stone. Thereupon the image can be supplemented with drawing using crayon and tusche before being etched, rolled up and printed in the normal way. As with gum transfer images, photocopy transfers can be treated singularly as an end in themselves. However it is more common for them to be used as a basis for further development, printing as a colour run in a multi-colour print.

Photocopy transfer is a valuable technique since it provides the opportunity to incorporate a broad spectrum of material. Just about anything can be photocopied, from drawings, paintings, graphics, text, photographs, to computer generated images. It is even possible to photocopy actual objects, such as the shells used by Belfast based artists Phillip and Margaret Napier in their print *Phil and Maggie* of 1998, printed by the author (see overleaf).

THE USE OF TRANSFERS ON STONE

Phil and Maggie, Phillip and Margaret Napier, UK. 26.4 x 17.6in. (660 x 440mm), 1998. A two-run lithograph. The image was developed using palm prints (of each artist), inked feather transfers and photocopy transfer. Collection of Paul Croft.

Halo, Phyllis McGibbon, USA. 10 x 6.6in. (250 x 165mm), 1993. A five-run lithograph employing photocopy transfer on stone, litho pencil and rubbing crayon.

Oda al Pajaro, Daniel Zelaya, Argentina. 11.2 x 13.2in. (280 x 330mm), 1996 A three-run lithograph. The image was developed using a gouache resist technique of transfer, inked feathers and drawing with crayon and tusche.

The quality of photocopy transfer is normally excellent and definition is generally fine enough to depict pixels from computer-generated imagery. Opportunity exists for pre-press planning, that can even begin on the computer; images are photocopied, collaged, drawn over and photocopied again. Once transferred to the stone, further manipulation using conventional techniques of drawing and printing creates exciting possibilities.

Toner, as has been noted, is a variable commodity and photocopies appear to vary depending upon the current state of technology and the brand of copier used. Certainly different types of copiers produce qualitative differences in image reproduction. It will also be found that some photocopies will react well to specific solvents and make excellent transfers, whilst others simply will not. Various solvents too have been used in the past to release the toner from the page and some experimenting will probably be required to ascertain which one will work best for you.

In the USA *oil of wintergreen* or *methyl salicylate* was favoured by many printers, since it not only made an excellent transfer but also appeared to cure the toner on the stone as well. As a major constituent of a remedy for rheumatism, it was deemed to be safe, but recent research has cast serious doubt over its safety in this application.

While *acetone* can be used successfully, some transfers on the stone tend to be weak in character and there may be some loss of definition. In my own experience I have found ordinary *lighter fuel* to be excellent, not only to produce a good transfer but also for curing the toner on the stone. Some brands seem to work better than others however, and you will need to test these too.

All solvents are of course dangerous, and each presents its own set of hazards. Whichever is used, always take the necessary precautions of wearing gloves, mask and using adequate ventilation.

Procedure for making a photocopy transfer

1. As with toner washes, photocopy transfers need to be made before any other drawing has occurred on the stone.

2. It is important that the freshly grained stone should be set up ready on the press centred on the press bed and with the bar-end brought up against the spacers. A scraper bar, wider than the photocopy but not as wide as the stone should be installed. Set the 'start-stop' positions so that the scraper bar remains resting on the stone at the start and finish of the transfer.

3. For photocopy transfers, the pressure should be set at *normal printing* pressure.

4. Experience demonstrates that the photocopy to be used needs to be as fresh as possible and certainly should be transferred to the stone within half an hour of being made.

The Fish Mosaic Tarragona, John Grant, UK. 24.8 x 36in. (620 x 900mm), 1999.
A four-run lithograph in which much of the colour was achieved by three separate
monotype runs. The stone containing photocopy transfers was then inked using a
series of small brayers and printed on top.

Aftertaste, Sara Ogilvie, UK. 23.8 x 30.4in. (595 x 760mm), 1999.
In this seven-run lithograph, Ogilvie drew the image as a monotype on acetate,
wiping and drawing through a film of roll-up black. This image was then transferred
to the stone and further developed with crayon and tusche. Other transfers were
made by inking wooden blocks of type and pressing these onto the stone.

5. The photocopy is placed face down onto the stone and held in position by taping the leading edge with a small piece of masking tape.

6. Taking the necessary precautions, apply solvent to the back of the photocopy and spread this evenly with soft tissue. Both lighter fuel and acetone tend to evaporate rapidly and it is necessary to work quickly to drench the paper sufficiently. As the paper becomes saturated, it is usually possible to see the image shining through the back of the paper.

7. Quickly cover the stone with two sheets of fresh newsprint, place the tympan on top and run the stone through the press twice under printing pressure.

8. Return the stone to the 'home' position, remove the tympan and newsprint and carefully peel back the photocopy, checking to ensure that the image has been transferred.

9. Unlike gum transfer paper, the photocopy transfer can be worked over immediately using conventional lithographic drawing materials.

Invariably all photocopy transfers are etched using just gum arabic, making processing very simple; unless the image appears unusually heavy following roll up, the second etch is also applied as gum. If, however, the photocopy has not transferred to the stone very well and appears quite weak, then the image should be strengthened with ink *before* it is etched. To do this, first dampen the stone with a gummy sponge and let it sit for a couple of minutes. Then keeping it damp, proceed to roll the image up using greasy roll-up black. At first the image may not appear to darken and there will probably be considerable scumming elsewhere. However it should be possible to fully ink the image and then to etch this with gum in the normal way.

Chapter 8

LO-SHU WASHES, MANIÈRE NOIRE, ACID TINT AND LINE ENGRAVING

■ Each of the processes outlined in this chapter are regarded as specialist techniques that offer unusual approaches for developing lithographs. As such, they are probably more suitable for experienced lithographers who have a good understanding and an intuitive feel for the medium. As with any techniques, however, practice and experimentation provide good experience and you should not in any way feel discouraged from trying them.

Prints produced as *manière noire*, *acid tints* and *line engravings* are often made exclusively using these techniques and have their own sense of integrity as finished pieces of work. *Lo-Shu*, on the other hand, is commonly printed as a run or in conjunction with conventionally drawn elements.

Whilst the resulting printed qualities may seem eccentric in appearance, they are distinctively lithographic in character, although it would be true to say that *manière noire* and *acid tint* are reminiscent of mezzotint and aquatint, and *line engraving*, not surprisingly, is regarded as the litho equivalent of metal plate engraving and etching. *Lo-Shu* washes and acid tint are both capable of being executed on stone and on plate, however the other two processes of manière noire and line engraving need to be made on stone.

Lo-Shu washes

In printmaking it is not uncommon for new techniques to be discovered by accident or as a result of misunderstanding, and *Lo-Shu* is one such example of a technique being discovered in this way.

Opposite: *Albuquerque Glyph Series II*, Paul Croft, UK.
15.2 x 11.2in. (380 x 280mm), 1997. A three-run lithograph by in which
Lo-Shu wash has been printed as the first run.

When Rebecca Bloxham, a graduate student at Brigham Young University in Utah, accidentally dropped some water containing gum onto her litho plates, she assumed that her images had been ruined for good. She noticed, however, that as the water dried, a reticulating pattern formed. Curious to see if this could be printed, she proceeded to make further experiments. Her successful results were subsequently presented to the Tamarind Institute in June 1981, who advised her upon further research and documentation[1].

Lo-Shu washes essentially rely upon the desensitising nature of gum arabic to form quite beautiful negative reticulating washes, seen as white against a dark printed field.

As the wash solution dries upon the stone; the minute quantities of gum suspended in the water appear to settle out and dry as finely deposited crystalline lines on the stone, effectively 'stopping out' in these areas and forming white lines when the rest of the stone is inked in black. Although similar in many ways to tusche washes, the reticulation of Lo-Shu tends to be more concentric and because they are seen as white, suggest a more ethereal feeling.

Applying *Lo-Shu* washes

Different types of gums have been tried and tested in *Lo-Shu* wash solutions, including cellulose gum (a synthetic gum) and hydrogum (derived from the mesquite plant), with varying printed results. For most printers, however, minute quantities of gum arabic are adequate for making up *Lo-Shu* solutions.

To make up a *Lo-Shu* wash solution, add about 3 drops of gum arabic to 1oz. (30ml) of water or 5 drops of gum to 2oz. (60ml) of water. Unlike conventional tusche washes, ordinary tap water appears to help in the precipitation of the gum, although distilled water can be used if preferred. It should be noted that if too much gum arabic is added to the solution, the resulting washes will 'fill in' and will appear overly white when they are printed. Conversely if too little gum is added, unsatisfactory reticulation will occur and the image will appear dark.

Washes are applied to the stone, puddled using a very clean brush free from contamination and any excess gum. The washes can be allowed to dry naturally or may be force dried using a hair dryer, which can help to create interesting patterns. Further applications can also be overlaid, although an excess of gum from the solution may cause filling in to occur. As the washes dry, it should be possible to see the gum reticulations as a faint tracery of lines against the surface of the stone. Once the drawing is complete, a border of gum arabic at least $1^{1}/_{4}$in. (30mm) wide should be painted around the edges of the stone and allowed to dry.

Processing *Lo-Shu* washes

1. Apply asphaltum over the image area as bounded by the gum margins, spreading it evenly and buffing it down well with a clean, soft rag. Allow this to dry and then apply a further coat of asphaltum in the same away.

2. The stone should now be dampened with water to remove the gum from the edges of the stone and to lift the washes.

3. Ensure that the water film is kept fine and then quickly roll up the image using greasy roll-up black and a leather roller. The image should be inked fully until the resulting washes are seen clearly against the black field of ink.

Bardo Prickly Pear, Catherine Chauvin, USA. 15.2 x 11.2in. (380 x 280mm), 1998. In this black-and-white print, *Lo-Shu* wash and crayon drawing have been printed from the same stone.

4. Assuming that the *Lo-Shu* washes have formed as intended, and good reticulation has occurred, apply rosin and French chalk and a 3–4 drop etch directly onto the stone. After about 60 seconds, remove the excess and buff the remaining etch down tight with clean cheesecloth.

5. The stone should be left to rest for at least one hour, after which it is washed out as normal, inked and second etched using the same etch strength. It will then be ready to print.

If the image has rolled up excessively dark, with little evidence of reticulation, too little gum arabic was used in the original wash solution. Further washes however can be added using a stronger solution, if the ink and all traces of grease are first removed from the stone.

To do this, first apply French chalk and then gum, which needs to be spread evenly and buffed down tight using clean cheesecloth. Wash the image out well using turpentine and then apply acetone to remove all traces of grease from the surface of the stone. New washes can now be applied and processed as before.

Contorted Self-portrait, Stephen McGoldrick, UK. 15.2 x 20in. (380 x 500mm), 1999.
A single-run lithograph printed on to Japanese Mulberry paper. The image
has been developed as a *manière noire* and drawn using a razor blade and
drypoint needle.
Collection of Paul Croft.

Cevennes Village, Simon Burder, UK. 4.2 x 5.6in. (105 x 140mm), UK.
Black-and-white lithograph using *manière noire* technique.

Conversely, if the image has rolled up very light, this suggests that too much gum was used in the wash solution and the image has filled in with the excess gum. In this scenario, additional washes using a weaker solution can only be applied if the stone is first counter-etched.

Using water-soluble pencils

As a final postscript to this technique, it is interesting to try drawing with water-soluble pencils, such as Caran d'Ache, that contain a measure of gum arabic as a binding agent. Applied to the stone and processed in the same way as for *Lo-Shu*, it is possible to develop white line drawings seen against a dark background.

Manière noire and acid tint

Manière noire and acid tint are also negative processes, that rely upon a dark field of ink being established upon the stone and the image formed in a subtractive manner, either by scraping away the ink using a sharp knife or metal stylus as in *manière noire*, or through controlled burning using weak etches as in acid tint.

Manière noire, the easier of the two methods, was first developed in 1832 by the French printer Lemercier who called the technique *lavis lithographique*[2]. Similar to mezzotint, the technique attempted to faithfully reproduce continuous tone and subtle variations in a range from the lightest of grey to black. Although not overly popular throughout the 19th century, it was used by artists such as Adolph von Menzel, Bresdin and later by Odilon Redon, Picasso and Rouault.

Acid tint, meanwhile, is relatively recent, first developed in 1964 by Ken Tyler, the then Technical Director at Tamarind Lithography Workshop, Los Angeles, and later improved upon by John Sommers working at the Tamarind Institute[3].

The precedent for acid tint was a process known as *lithotint*, invented by the English printer Charles Hullmandel in the 1820s and later adopted by Thomas Way working for James McNeil Whistler.

Both printers were secretive, and not much is known about either technique; however, it appeared to involve using rosin, applied to the stone like aquatint, and etches of varying strength, creating subtle tones and texture. The atmospheric effects of some of Whistler's prints appear to owe much to the use of this technique, although it is unlikely that Way ever allowed him to see how the images were processed. The acid tint process similarly makes use of varying strengths of etches to carefully burn the image into a specially prepared ground of black ink. The resulting image is soft, subtle and closely resembles the tone and texture of aquatint.

Preparing the ground for *manière noire*

The procedure for manière noire is relatively simple. In the first instance a dark field must be established upon the stone, providing a suitable ground for the image. Ideally, very greasy ink such as Charbonnel Noir à Monter is required, although a greasy roll-up black will probably work equally well.

1. Using a stone grained to at least #220, establish the image area upon the stone and paint a gum border of at least 1¼in. (30mm) wide around the edges.

2. Apply two coats of asphaltum and buff this down in to an even film.

3. Using greasy roll-up black or Noir à Monter, proceed to *dry roll* the stone – inking without using water until the stone is quite dark.

4. Use a damp sponge to wash off the gum and continue inking brusquely to lift off any scum that will have formed over the gummed borders. Persistent areas of scumming can be removed using a caustic eraser and a sharp blade.

5. Dry the stone, apply rosin and French chalk and then apply a first etch of 3 drops directly over the entire stone.

6. A stronger etch of about 20 drops can be applied to the borders to prevent them from inking during printing, ensuring that this etch does not leak into the inked area. Mop up any excess etch using a well wrung out sponge, and then apply further gum, buffing this down tight with soft cheesecloth.

7. The stone should be left to rest for at least one hour. It may then be re-gummed, buffing the gum down tight with clean, soft cheesecloth.

8. Wash out the image with turpentine, apply asphaltum and ink the stone with roll-up black until it is fully inked. Fan the stone dry.

Drawing and etching *manière noire*

At this stage the stone is dusted with French chalk to dry the ink film for drawing. If desired, the image can be traced onto the stone first, using red oxide paper, and this will provide a useful guide when scraping through the ink to create the image. Any sharp instruments can be used to draw with, such as sharp razor blades, drypoint needles and Tam O'Shanter Snake Slip Stones.

When drawing, only the ink film needs to be abraded and heavily incising the stone surface should be avoided. It is tempting sometimes to

The Bend United I, Robert Jancovic, Slovakia. 27.4 x 38.2in. (685 x 955mm), 1989.
A three-run lithograph printed from a single stone in yellow, violet and black. The
image was drawn with etching needles as a manière noire. Printed by Hanke Ernst.

overly lighten areas but as in mezzotint, it is advisable not to overwork the
image if the intention is to achieve a range of subtle tones. Use a clean, well
wrung out sponge to wipe the surface of the stone occasionally, to remove
any debris caused by the scraping. Once the image has been completed,
again wipe the surface clean with a sponge, dry the stone and apply rosin
and French chalk.

A moderately strong first etch of about 12 drops should be applied
directly over the whole of the image. The second etch applied after the
image has been rolled up again will probably need to be of a similar
strength, and possibly a further third etch may be required if the image
appears to be unstable and starts to fill in during printing.

Preparing the ground for acid tint

A similar ground of ink must also be formed on the stone for drawing
with the acid tint technique. Although the same process described above
for manière noire could be used for this, it is better to establish the grease
on the stone using a specially prepared mixture called *shop black*. This
excessively greasy mixture of ink and asphaltum is used because the
resulting ground can withstand the rigours of etches much more than if
ink alone is used.

Shop black is easily mixed and a stock is normally kept in the workshop
for whenever required. As well as being used for acid tint, it is also ideal for
drawing large 'flats' that are to print a solid colour or tone.

Constantly, Catherine Chauvin, USA.
9.2 x 12in. (230 x 300mm), 1999.
A four-run acid tint printed in
yellow, red, blue and black. The final
run also used photocopy transfer and
crayon drawing.

Untitled, Paul Croft, UK. 15.2 x 10in.
(380 x 250mm), 1994. Black-and-white
acid tint and manière noire.

To mix up a stock of shop black add 1 part Noir à Monter to 1 part asphaltum and thin to a creamy consistency using about 1 part turpentine or lithotine.

To prepare the ground:

1. Using a stone grained to at least #220, establish the image area upon the stone and paint a gum border of at least 1¼in. (30mm) wide around the edges. Gum can also be used at this stage to stop out any areas of the image that are to remain white.

2. Using a brush, apply shop black to the image area, obtaining a fully solid covering. Allow the shop black to dry and then apply rosin and talc.

3. Apply a 5-drop etch to the whole of the stone for about 60 seconds. Remove the excess etch from the stone and then buff the remaining gum down tight using clean, soft cheesecloth.

4. The stone should be left to rest for at least one hour. It is then re-gummed, buffing the gum down tight with clean, soft cheesecloth.

5. Wash out the shop black using turpentine or lithotine.

6. Instead of applying asphaltum and rolling up the image area, a tint ground using a mixture of shop black thinned with turpentine to a smooth consistency must now be applied, using a soft rag. It is important that this ground is applied *evenly* across the whole surface of the image area and is totally free of *any* streaking. Several applications and some practice may be required to achieve a ground that is neither too thick nor too thin. The resulting ground buffed down should appear a consistent charcoal brown-black in colour.

7. Dust French chalk over the ground to dry the ink film. Do not apply rosin to the stone.

8. Lastly, use a damp sponge to wash away the chalk, gum borders, and any gum stop outs that may have been added. Fan the stone dry. The stone is now ready for drawing.

Drawing the acid tint image

By quite literally painting with etches, the drawing is established on the stone as a result of the etches burning in to the tint ground, causing lightening of those areas to occur. A range of tone is also possible by using etches of different strength. However, this is further complicated by both how much etch is actually applied, and how long each etch is allowed to remain on the stone. In essence, stronger etches applied for longer periods of time will result in lighter tones, weak etches applied for shorter periods will provide darker ones. Some practicing of this technique will obviously be required to ascertain which etches appear to work best on the stone. However the following etch strengths are suggested as a reasonable starting point:

Weak etch 4 drops of nitric acid to 1oz. gum will form dark tones
Medium etch 8 drops of nitric acid to 1oz. gum will form mid tones
Strong etch 12 drops of nitric acid to 1oz. gum will form light tones

To create the drawing on the stone:

1. If desired, the image can be traced on to the ground first using red oxide paper and this will provide a useful guide for applying the etches to the stone.

2. Starting with the weakest etch, paint this onto those areas of the image that are to be seen as the darker tones. Treat the etch as a drawing ink and ensure that not too much is applied to the ground. The etch should be applied for just 30 seconds and then carefully removed using a well wrung out sponge. Fan the stone dry and reapply the same etch a second time.

No clear indication that the etch has actually acted will be apparent, although subtle 'brushmarks' should be just about visible on the surface of the ground.

3. The stone should be well rinsed after each application of etch and fanned dry before the next strength is used. Unfortunately this may require the drawing to be retraced with red oxide as well.

4. After the final etch has been applied, wash off any residue gum with a damp sponge and fan the stone dry.

Processing the image

Processing an acid tint image involves the technique of *rubbing-up*, a quite difficult process for the uninitiated and also very messy. Ideally, this should be done with the stone placed over the graining sink or close to a water supply and you will also need to prepare the following:

- 10¼oz. (300ml) gum water – mixed as one part gum arabic to one part distilled water.

- Rubbing-up ink – Noir à Monter mixed with turpentine to a creamy consistency on an inking slab or in a saucer.

- About 2–3 small sponges cut to about 2½in³. (6cm³)

1. Using one of the small sponges, apply the rubbing-up ink to the whole of the image area.

2. Once the image has been rubbed up, take another sponge and rub in the gum water. It is most important that this sponge is merely dampened with the gum water solution and the sponge is kept moving across the stone; if excess water is used or is allowed to remain sitting on the image, water burn and streaking will certainly occur.

3. The stone is rubbed up in this manner three times, by which time the image should have fully developed and the drawing with a clear range of tone should be visible. Sponge off any excess water and fan the stone dry.

Assuming that the image appears to have inked up well, rosin and French chalk are applied and the stone is etched with a 5 drop etch. The stone is allowed to rest for one hour before being washed out and rolled up in the normal manner. A further second etch of 5 drops is applied, unless stronger etch strengths are required for lightening some of the areas. The stone will be ready for printing after one hour.

Still Life, Nebojsa Lazic, Yugoslavia. 15.2 x 20.4in. (380 x 510mm), 1994. Black-and-white acid tint.

Line engraving on stone

The *engraved manner* is a process that was first described by Senefelder in his treatise, *A Complete Course of Lithography* published in 1818. In this early use of stone engraving, the stone itself was engraved and the image printed intaglio. Each time a print was taken, ink would be wiped into the engraved lines and the excess wiped away from the surface of the stone, exactly in the same way that a metal plate is printed. The resulting print also shared the attributes of an intaglio print whereby the printed lines are seen raised and embossed upon the paper.

A French printer by the name of Mairet, in a little-known book entitled *Notice sur la lithographie,*

Cricket, Erika Adams, USA. 15.8 x 13.2in. (395 x 330mm), 2000. A two-run lithograph drawn as a line engraving on stone and printed with cine collé. In this proof some additional hand colouring has been made using watercolour.

Paddle, Jeffery Sipple, USA. 20.4 x 15.2in. (510 x 380mm) , 1998.
A four-colour acid tint printed in yellow, magenta, cyan and black.

first published anonymously in 1818, describes another technique known as *dessin à la pointe*, which is certainly lithographic in character. In this technique, the drawing is scratched through a gum coating applied to the stone and the image processed to print planographically[4].

This process of line engraving was used considerably throughout the 19th and early 20th century, partly for reproducing metal plate engravings and also for printing certificates and labels. Since the 1920s, however, the process has been largely forgotten and very few artists have either made stone engravings or even incorporated the technique in to their images.

During the 1970s the process was researched and revived by the Tamarind Institute, and while the technique is still rarely used, it is an interesting process capable of producing a beautiful quality of printed line.

The technique described here is one that has been adapted from a method originally outlined by John Sommers and Clinton Adams in 1974, and was learnt during my own training at Tamarind in 1995[5].

Procedure for stone engraving

For stone engraving it is necessary to use a highly polished surface and a good quality of stone, ideally a grey stone or a hard yellow stone grained to at least #320. It is very easy to scratch a stone when it is polished to this degree; this can be avoided if a small polishing stone is used with small amounts of fine grit and copious amounts of water. Grain the stone slowly and keep the passes short, and ensure that the stone is rinsed well between applications of grit.

To prepare the stone and make the drawing:

1. First apply a 10 drop etch to the whole surface of the stone, buffing this down tight with clean, soft cheesecloth. This essentially establishes a gum adsorb film over the stone and ensures that the negative areas of the image remain free of ink.

2. The stone should be left to rest for only about 15 minutes.

3. Using a clean sponge, the majority of the gum is removed from the stone leaving a thin film of watery gum on the surface, which is again buffed down tight using cheesecloth.

4. The image can now be made using a sharp instrument such as a drypoint needle, or ideally a diamond-tipped stylus. When drawing the image, it is only necessary to scratch through the gum film exposing the uppermost surface of the stone. Wherever possible, the surface of the stone itself should not be incised at all, since this would in fact inhibit the subsequent printing of the image.

5. Having completed the drawing, use *shop black* diluted with turpentine and rub this well into the drawn lines. Apply the mixture several times, ensuring that all of the lines are filled with grease.

6. Using a damp sponge wash off the remaining gum film and proceed to roll the image up using a leather roller and a lean ink, inking until the image is full and strong in appearance.

7. If the image is particularly delicate and the inked lines are fragile, breaking up every so often, rosin can be applied which will stick to the ink and enable the lines to be inked further.

8. Apply rosin and talc to the inked image and then apply a specially prepared etch that uses 3 drops of nitric acid and 2 drops of phosphoric acid mixed with 1oz. (30ml) of gum arabic. The presence of phosphoric acid helps to desensitise the stone and, since it is less reactive than nitric, ensures that the etch works more slowly and does not damage the drawing. Remove the excess etch and buff the gum film down tight with cheesecloth. Leave the stone to rest for one hour.

After application of this etch it should be possible to print the stone in the normal manner. Further engraving can be added if desired by washing off the gum film in the same way, drawing with a needle and proceding as above.

1 Rebecca Bloxham, 'Lo-Su Washes', *Tamarind Technical Papers*, Volume 6.
2 Michael Twyman, *Lithography 1800–1850*, Oxford University Press, 1970.
3 John Sommers, 'Acid Tint Process', *Tamarind Technical Papers*, Volume 7.
4 Michael Twyman, *Lithography 1800–1850*, Oxford University Press, 1970.
5 John Sommers, 'Engraving on Stone', *Tamarind Technical Papers*, Volume 1.

Chapter 9

ACRYLIC REVERSALS AND SOAP WASHES

The two somewhat unorthodox processes outlined in this chapter offer a useful extension of lithographic practice that provides artists with an increased range of possibilities in both image development and mark making.

The *Acrylic Reversal Process* is a commonly used and valuable technique for producing a negative image from an already existing positive one. Otherwise known as *transposition*, this technique enables the image to be printed both in positive and in negative, allowing for exciting opportunities to develop fairly sophisticated colour images using a single stone.

The use of soap washes on stone, however, appears to be a relatively unknown technique that was introduced to me by James O'Nolan, Director at the Graphic Studio in Dublin. Used considerably at that studio, the principle for soap washes appears to defy *all* lithographic logic and it is not clear as to why they should work at all. For the more adventurous lithographers amongst you, therefore, this may prove to be an interesting technique for future research.

The Acrylic Reversal Process

Reversals, otherwise known as the transposition of images, appear to have been developed by the commercial printing industry during the 19th century, in response to competition from letterpress printing. Transposition effectively enabled both positive and negative versions of the same image to be made, allowing for multicoloured images to be printed. At that time, before photoplate lithography had been successfully developed, this process was a useful and cost effective way of printing labels and packaging.

Throughout the 19th century, a number of different methods for reversing images were employed, and many of these were involved and time consuming. In one process, for example, excessively strong etches were used to etch the stone, putting the positive image in to high relief. The stone would then have been counter-etched and tusche applied to the whole surface, resulting in a temporary loss of the image. Following processing, the raised positive area would then have been physically honed down until only the negative remained on the stone.

The search for a simpler method was once again carried out by the Tamarind Institute during the late 1960s. The acrylic reversal process adopted by me and used by many artists worldwide is one that was first described by John Sommers in 1974[1], although it has since been refined by successive printers working at the Institute and elsewhere. In this process an acrylic polymer is used to effectively mask off and protect the negative areas of the image, while the positive is chemically deleted.

Nowadays this acrylic reversal technique is particularly useful for print-ing negative images where photoplate processes are unavailable, and it is used by some artists to introduce an additional colour run. By printing both positive and negative images together and also slightly out of register, an interesting *posterised* effect can be achieved, similar to that caused by printing an etching plate both in relief and in intaglio.

While a single stone or plate can be used to print both the positive and the ensuing negative image, it should be realised that the positive is eliminated during the production of the negative. As a consequence the positive image should first be printed and editioned before the reversal is made. Alternatively, the positive image can be transferred to another stone using gum transfer paper and using this second stone to create the negative. This is useful since it enables alterations to be made on both the negative and positive images, and can also allow for a greater degree of colour trial proofing of the image before the edition is finally made.

Procedure for Acrylic Reversal

The basis of this process is dependent upon the use of a suitable acrylic polymer that is both durable and resistant to water and turpentine, but can ultimately be removed using a strong solvent or cleaner. Through my own experience I have found that either Daler Rowney's or Windsor & Newton's Acrylic Matt Medium to be ideally suited for this process.

1. Assuming that the image to be reversed has just been printed, the stone should now be fully inked using roll-up black. Alternatively, if a second stone is being used with a transfer image, process this fully – first and second etch – and then wash out the image again and roll up using roll-up black.
 In each case ensure that registration marks have been clearly marked on the stone(s).

2. The stone should now be counter-etched in the normal manner, using either acetic or citric acid. Rinse the stone well, fan it dry and then apply French chalk, dusting off any excess.

3. Using sellotape, mask off a border all the way around the edges of the image to ensure that these areas do not ink up as part of the negative image.

Examples of a positive image, its acrylic reversal negative, and both printed together.

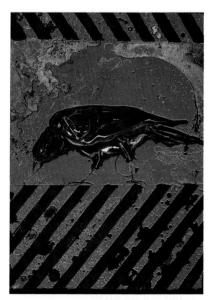

Raven, David Mohallatee, USA. 20.4 x 15.2in. (510 x 380mm), 1994. A two-run lithograph using the acrylic reversal process. Printed in red and black, the registration has been purposefully offset to create a posterised effect.

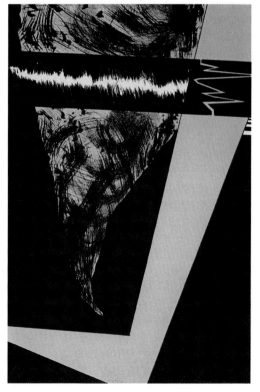

Vortex, Frank Janzen, Canada. 22.8 x 15.4in. (570 x 385mm), 1994. A two-run lithograph by , using the acrylic reversal technique. In this print the white areas were stopped out with gum arabic after the acrylic had been removed and before asphaltum was applied for rolling up the negative.

4. Now mix the acrylic matt medium, adding 1 part acrylic to 1 part distilled water.

5. The acrylic should now be applied to the stone using a small piece of clean sponge. It is important that this application is spread thinly and evenly over the whole surface of the stone and is buffed down tight using clean cheesecloth.

6. The acrylic needs to be cured using a hot hair dryer for about 10–15 minutes. A further two or three applications of acrylic should then be applied and cured in the same manner. After the final application, allow the stone to rest for at least one hour.

7. Wash out the positive image using turpentine or lithotine, ensuring that as much grease and ink as possible is removed. Remove the sellotape borders.

8. A 4-drop etch should be applied to the whole stone at least three times, allowing each application to remain on the stone for at least 60 seconds. This effectively desensitises the stone, eliminating the positive image. After the final application, apply fresh gum arabic and buff this down tight with some cheesecloth. Allow the stone to rest for at least one hour.

9. Using appropriate ventilation and protective gloves and mask, the acrylic overlying the negative is now removed using a strong solvent such as acetone or lacquer thinner, applied using a soft rag. Four or five applications may be required to remove all traces of the acrylic from the stone.

10. Lastly, apply asphaltum and ink the stone in the normal manner. The negative should appear fully inked while the positive will remain ink free.

11. The image should be given a first etch of 3 drops and a further second etch of similar strength.

Soap Washes

The function of fats and oils in lithography is well documented; being greasy, they are obviously crucial in the drawing and subsequent printing of images. Drawing materials containing fatty acids tend to adhere well to the surface of stone, and being oleophilic and water-repellent, enable the image to be inked and printed. Both vegetable and animal fats including olive oil, linseed, lard and tallow have been used, together with other substances such as soap, wax and shellac in the composition of lithographic crayons and tusches.

Soap, in the form of oleo-manganate of lime, is of course an important by-product formed during etching, and its presence within the structure of the stone is vital for printing. The inclusion of soap in drawing materials also improves the texture of crayons and helps tusche to emulsify when it is dissolved in water.

Soap itself, however, also contains high levels of fatty acids and as a result can potentially be used to draw on the stone. The application of soap as a form of *liquid tusche wash* is not such an unusual concept and I have heard of printers in the past who have made their own crayons and inks using a variety of different recipes.

The process of 'soap washes' described here, however, is at the same time both interesting and seemingly implausible. The process was made known to me by James O'Nolan, director of the Graphic Print Studio in Dublin, who himself had learnt of the process from two Irish artists, Michael Farrell and Richard Gorman, both of whom had worked at lithography studios in Paris.

The process seems to be particularly useful for the printing of flats and for areas of painterly drawing. In many of the examples illustrated here, the technique is used mainly for building up layers of colour over which drawing, using conventional tusche washes, is then printed. The technique appears also to require minimal processing, and additions and deletions can be made rapidly, even during printing, thus allowing for a more spontaneous and less time-consuming approach.

Some research and experimentation using different types of soaps will certainly be required in order to find which type will work best for you. A block of pure olive-oil soap, such as can be bought at good chemists or health food shops, can be used like a large block of watercolour and painted on to the surface of the stone with brush and water.

Interesting wash effects can also be achieved using a solution of Lux soap flakes that are dissolved in water in varying proportions. When dissolving the soap, ensure that the water is heated and that the mixture forms a gel when cooled.

Procedure for using soap washes

This outline by James O'Nolan is included here in edited form with added comments and observations from myself:

1. Ensure that the stone being used is large enough to carry both the image and paper and has been freshly grained to at least #220. Ideally work with the stone set up on the press bed and ready for printing.

2. As with stone engraving, the stone must first be desensitised using either gum arabic or a weak etch of around 5 drops. This should be applied to the whole surface of the stone in the

Bog Pool (Evening Bogland), Sean McSweeney, Ireland. 22.4 x 30.4in. (560 x 760mm), 1989. A three-run lithograph. Each of the three stones used in this print was drawn using the soap wash technique.

Untitled, James O'Nolan, Ireland. 16.4 x 13.6in. (410 x 340mm), 1995. A six-run lithograph printed using five stones drawn with soap wash and a key image using tusche.

Tory Island 5, Niall Naessens, Ireland. 9.2 x 6.8in. (230 x 170mm), 1999. A four-run lithograph printed using three stones drawn with soap wash and a key image using tusche and crayon.

normal manner and buffed down tight. Leave the stone to rest for about 15 minutes.

3. Once you are ready to draw on the stone with the soap washes, the gum coat over the stone should be removed with a clean sponge and water. This too is similar to stone engraving where the gum is removed to leave the thin gum adsorb film on the surface of the stone. As such, the stone will remain insensitive to grease.

4. The drawing can now be made on the stone with the surface either wet or dry. It is better to apply the washes as a watery solution and it is important to avoid using the soap in a paste like manner.

5. Once the image is complete, the soap should be quickly removed with one or two sweeps of a sponge and using copious amounts of water on the stone. This action is critical: any excess fat in the soap must be carried off in the water otherwise it will be spread to unwanted areas of the stone and will spoil your image.

6. Assuming that all has gone well, the soap washes will now miraculously have penetrated the gum adsorb film and, although colourless, will be clearly visible as they will be rejecting the water on the stone.

7. At this stage the image can now be inked in the normal manner, using a good printing black or colour ink if preferred. If the resulting image appears as intended, no further processing will be required and the stone will even be stable enough to allow editioning to occur!

8. Alternatively, the image may be further modified using a moderate to strong etch of between 8 and 12 drops and applied to the image much in the same way that etches are used in acid tint. Through experience it will be found that lighter tones can be achieved by leaving the etch on the stone for longer. Use of a stronger etch can also delete whole areas as required. When applying etches to the stone, it is advisable to print the image first to help strip off some of the ink from the stone.

9. Further additions can easily be made by applying the soap washes as before, and you can add and remove as often as you like until the desired effect has been achieved.

The process described above certainly has been proven to work, but how it is possible to draw over a desensitised stone is not entirely clear. One possible explanation is that the process is a 'painterly' version of stone

engraving and the soap in some way breaks the gum adsorb film and enables these areas to be inked. Yet it seems evident that the soap is in some way able to penetrate the gum and become fixed within the structure of the stone. Other aspects of the technique are very similar to the acid tint process as well.

In the words of James O'Nolan, 'In practice although you have no processing to do, quite a lot of time can be spent adding and subtracting, proofing and modifying at this stage, but the method allows great flexibility and the effort is well worth it.'

Land Line, Felim Egan, Ireland. 11.6 x 11.6in. (290 x 290mm), 1997.
A five-run lithograph printed using four stones drawn with soap wash and a key image drawn with crayon.

1 John Sommers, 'Polymer Transposition', *Tamarind Technical Papers*, Number 2, July 1974.

GLOSSARY
Terms, techniques and materials

Acid tint A method of drawing using relatively strong etches to burn the image in to a darkened field on the stone, such that the resulting image is seen as a series of grey tones against a dark background.

Acrylic reversals A technique by which a negative is formed on the stone from an existing positive image that has either already been printed or has been transferred to a second stone using transfer paper. An acrylic polymer is used to protect the counter-etched negative surface while the positive areas are deleted using gum etches. The acrylic is then removed, asphaltum applied and the negative rolled up in ink.

Asphaltum Sometimes known as 'washout solution'. A greasy substance of bituminous extraction used in lithography for reinforcing images areas on the stone.

Baumé The term used to denote the specific gravity of gum arabic. In lithography, gum should ideally be of low viscosity but with a high 'solid content'. Typically gum arabic of 14°Baumé is used although 12°Baumé can be employed.

Bleed print A print in which the image is either the same size or larger than the paper and is thus seen as running off the edge of the sheet.

Body The term used to describe the consistency of printing ink enabling it to be rolled out evenly.

Calendering Paper that has a tendency to stretch under pressure that would cause problems of registration, or has a rough texture should be calendered by running each sheet through the press twice under printing pressure.

Chine Collé The technique of collage, using typically, fine Japanese tissue to develop localised areas of colour and texture within an image. Whereas in intaglio collé is applied during printing, in lithography, collage material is first cut to size and adhered to a substrate of heavier printing paper before the image is printed. A good use of chine collé will utilise collage shapes that are sympathetic to the overall design and should only be detectable from evidence of colour.

Chromolithography A sophisticated method of printing colour that involved the use of carefully drawn tonal images, subtle overprinting of colours and pinhole registration. Developed by Charles Hullmandel as 'lithotint', it was much used by Thomas Shotter Boys in the 1830s.

Closing The term used to describe the closing of the stone once printing has been finished. Closing always involves 'tight gumming' where French chalk is first dusted over the image and gum arabic is then applied and buffed down tight with cheesecloth.

Colour stretch The ability of a colour to print a range of tone. Colours such as black and blue have a greater stretch than a colour such as yellow.

Counter etching The process of re-sensitising a stone after it has been etched to allow for additional drawing to occur. Dilute acetic or citric acid is used to strip away the gum adsorb film on the stone.

Diametrically opposed surfaces As a result of etching the stone, two surfaces that have distinct and opposite properties form simultaneously on the stone. In the first, non-image areas become hydrophilic and grease repellent; in the second, image areas become oleophilic and water repellent.

Dry roll This occurs when the stone is allowed to dry during inking. Ink adheres to negative areas of the image because of the absence of moisture.

Element The term used to denote the surface from which a lithograph is printed. *Printing elements* include stone, marble, aluminum plates, zinc plates, plastic plates, paper plates, photoplates, wood, etc.

Etch A mixture of gum arabic and nitric acid (for stone) used in the processing of images. Etch strengths are always mixed and expressed as drops of nitric acid per 1oz. (30ml) of gum arabic. Also known as *gum etches*.

Etching The term used to describe the processing of a lithographic drawing to enable the image to be printed. Not to be confused with the intaglio process. Etching normally includes a *first etch* that establishes the image and a *second etch* that will stabilise the stone for printing.

Extender base Also known as transparent base or transparent white. Colourless medium added to colour inks for increasing transparency.

Fanning Drying a stone with either a fan or a hair dryer.

Filling in The term used to describe the loss of detail and definition caused by overinking or as result of underetching. Commonly occurs in areas of reticulated wash, which can become solid and flat in appearance.

Flat An area of continuous tone in a drawing that is intended to print as a solid colour or blend of colour.

Flocculation This occurs when printing ink absorbs water and essentially becomes waterlogged. Ink loses tack, colour diminishes as each print is pulled and eventually the ink begins to disintegrate.

French chalk Talcum powder used mainly during etching helps to break surface tension and allows the gum etches to make close contact with the drawing and stone.

Ghost image Subsurface copy of an image seen during graining, caused by the penetration of grease in the form of oleo-manganate of lime.

Ghosting A halo effect that develops particularly at the edge of flats during printing, caused by not using a variable rolling pattern.

Graining The method of resurfacing a stone using carborundum grit and a levigator to remove a fractional layer from the surface of the stone. Graining is used to remove an existing inked image, to ensure that the stone is level, and to re-sensitise the surface for the next image to be drawn.

Gum adsorb film A molecular layer that appears to be deposited from gum in all the negative areas of the image not occupied by particles of grease. Permanent until removed by graining or counter-etching, it is hydrophilic and helps to repel ink from these areas.

Gum arabic Substance obtained from the acacia tree that grows in the Middle East, India and Sudan. Gum arabic is important primarily for its desensitising effect on the stone, and is used in etching and for stopping out areas of a drawn image.

Gum coat A thin layer of wet gum arabic applied to the stone during etching, through which gum etches are applied.

Gum sponge A small sponge normally used for gumming stones and for picking up etches. Not used for damping the stone during inking and printing.

Hones Erasers used to remove and correct unwanted areas of drawing. Hones can be made of rubber, caustic, pumice or a special type of stone known as Tam O'Shanter Snake Slip Stone.

Hydrogum A natural occurring gum derived from the mesquite plant. Being thinner that gum arabic, hydrogum is used by some printers for making up transfer paper and as a stop out on the stone, especially when applied using an airbrush.

Hydrophilic Water loving or water attracting, and the opposite of oleophilic. Hydrophilic surfaces on the stone attract moisture that repels printing ink in these areas.

Infusion line A mineral vein or thin line of quartzite material that is commonly seen running across and through the thickness of a lithography stone. Infusion lines can sometimes affect the resulting image by printing as white or dark lines.

Inking station An area set aside in a workshop used for laying out ink and for inking stones during etching and proofing.

Key image In colour printing the key image is the drawing that will often be printed as the final run to 'pull the image together'. Quite often the key image is drawn first and other colour runs are devised from it.

Level The term used to describe the uniformity of flatness of the stone, checked periodically using a straight edge, especially during graining.

Levigator The heavy metal tool composed of a large smooth metal disc and a handle used for stone graining.

Loose gumming Procedure for gumming the stone without using French chalk. Commonly used in colour trial proofing to facilitate changing colour without the need for a full closing and subsequent wash out.

Lo-Shu wash A negative wash technique using very small quantities of gum arabic suspended in water, resulting in white reticulated patterns.

Manière noire A method similar to mezzotint for creating an image by scraping through a darkened field so that the resulting drawing is seen as white against black.

Modifiers Substances added to colour printing inks that will help to alter the tack, viscosity and body of the ink. Examples include varnishes and magnesium carbonate.

Oleo-manganate of lime A very greasy soap like substance that is created within the structure of the stone during etching. Being oleophilic it attracts ink and helps the image to ink up and print.

Oleophilic Grease loving or grease attracting, and the opposite of hydrophilic. Oleophilic surfaces on the stone attract ink and print as image areas.

Pass (graining) The term used to describe the period of graining from the moment that carborundum grit is applied, continuing until it is no longer possible to move the levigator easily, and a cement like substance has formed on the surface of the stone.

(printing) See also Set of Rolls.

Planographic The term used to describe the method of printing from a totally flat surface, such as lithographic stone, lithographic plate or perspex – as in monotype.

Polyautography The name by which lithography was known in England until as late as 1812.

Proof A proof is normally considered to be a trial print that is taken from the stone after it has been processed. *Trial Proofs* (TPs) are the equivalent of state proofs, and enable the artist to see what further changes are required to finish the print. *Colour Trial Proofs* (CTPs) are made during colour printing to help obtain the correct colours and sequence of printing.

Push A somewhat ugly 'pillowy' texture that occurs within the printed ink film. Caused in part by the paper sliding slightly over the stone during printing and also by over-inking, excessive pressure and using too soft an ink.

Red oxide paper A non-greasy transfer paper used for tracing information onto a stone, prior to drawing with lithographic materials. Red oxide paper is easily made by dusting red oxide over a clean sheet of newsprint. Conté crayon can also be used in a similar way for sketching out drawings on the stone.

Registration The method by which an image is correctly positioned on the paper during printing, ensuring that multiple layers are seen in true relation to each other. Methods of registration include T-bar, pinhole and tab registration.

Reticulation The manner in which tusche washes dry upon a stone, creating an intricate web-like structure of delineated marks that is for many lithographers highly desirable.

Rollers Leather rollers used for proofing and printing in black need to be well maintained and during periods of continuous use, need to be scraped back at least once a week to remove the build up of excess ink. Holding the roller in a stand, use a blunt palette knife to scrape the length of the roller in each direction, working your way around the circumference and avoiding excessive pressure, which might damage the roller surface. Rollers that are not to be used for a period of time, should first be scraped back, rolled up in a soft ink and sealed with cling film or a polythene bag. Always store rollers in a stand to avoid flattening.

Rosin Powder derived from turpentine, used mainly in the etching to help protect the greasy drawing from the excess rigour of gum etches.

Rubbing-up[1] Procedure for applying colour ink on the stone at the start of printing. Instead of asphaltum, diluted ink is wiped and buffed down over the image area before being inked as normal.

Rubbing-up[2] A technique of alternately applying diluted ink and gum water used for processing acid tint images.

Run Colour prints are described as having been printed with a number of runs rather than colours, as sometimes more than one colour can be printed from the stone as a blend or split roll. Ideally a separate element is used for each run but some artists prefer to use a single stone and to grain this between runs.

Saponification The formation of oleo-manganate of lime or soap during etching, caused by the union of acid, calcium carbonate and grease.

Set of rolls Also described as a set of passes – the number of rolls used across the stone during inking before the roller must be recharged and the stone sponged again.

Shop black A greasy drawing medium mixed 1 part Noir à Monter and 1 part asphaltum, and thinned with turpentine. Use for establishing flats, and in acid tint.

Soap wash A technique of drawing using dilute solutions of soap applied directly on to the stone. Unorthodox in that drawing occurs upon an already desensitised surface, soap washes appear to require the minimum of precessing and can be printed almost immediately. Used primarily for developing underlying 'painterly marks' and 'flats' that are to be overprinted using conventional techniques. Possibly of French origin, it is used much by the Graphic Print Studio in Dublin.

Spot etching The process of etching an image using a number of different strengths of etches applied to appropriate areas of the drawing using a soft brush.

Steindruckery The name, meaning chemical printing, given to lithography by Senefelder.

Stripping Procedure for removing ink from the stone by printing onto sheets of newsprint without further inking. Commonly used during colour trial proofing for facilitating change of colour.

Tack The term used to describe the stickiness of printing ink and its ability to adhere to the roller and the image.

T-bar An effective method of registration that employs a T- and a bar-mark on the stone to match up with similar marks placed on the reverse side of each sheet of paper.

Toner wash A wash solution composed of photocopy toner and distilled water or surgical spirit, used for creating tusche-like washes.

Tracking Using a roller in a consistent manner, avoiding deviating at an angle. Important for avoiding roller and lap marks during printing.

Tusche Lithographic drawing ink used with a brush to create painterly marks. Produced in liquid, paste and tablet forms, tusche can be dissolved in either water or solvent to create a wide range of reticulation and marks.

Washing out The process of removing drawing materials or an inked image from the stone using pure turpentine or lithotine during etching or printing.

Water burn This can occur as the stone is inked, either between etches or at the start of printing. Caused by excessive water being allowed to remain on top of the asphaltum image. Streaking and image impairment can result.

Wedge The term used to describe the unequal thickness of a lithography stone. A stone is said to be *wedged* if it is thicker at one end than the other.

Wet wash A technique of washing out the image where no protective gum coat is on the stone. Sometimes used during roll up between etches and during printing. Sometimes used in emergency if excessive filling in has occurred to remove ink, to enable the stone to be inked using leaner ink.

LIST OF SUPPLIERS

UK

R. K. Burt & Company Ltd
57 Union Street, London SE1 1SG.
Tel: 020 7407 6474 Fax: 020 7403 3672
Email: sales@rkburt.co.uk
Paper suppliers.

Falkiner Fine Papers
76 Southampton Row,
London WC1B 4AR.
Tel: 020 783 1151 Fax: 020 7430 1248
*Specialist and suppliers of printing papers
and printing supplies including adhesives
and chine collé.*

Chris Holladay
Modbury Engineering,
Tel: 020 7254 9980
*Engineer extraordinaire,
press moving, repairs, etc.*

Intaglio Printmakers
62 Southwark Bridge Road,
London SE1 0AS.
Tel: 020 7928 2633 Fax: 020 7928 2711
*Suppliers of a wide range of printmaking
materials including inks and lithographic
drawing crayons, tusches, etc.*

T. N. Lawrence and Son Ltd (mail order)
208 Portland Road
Hove, BN3 5QT.
Tel: 01273 260260
Email: artbox@lawrence.co.uk
*Suppliers of printmaking and
artists' materials.*

John Purcell Papers
15 Rumsey Road
London, SW9 0TR. Tel: 020 7737 5199
Paper suppliers.

Rolloco
72, Thornfield Road, Middlesborough,
Cleveland TS5 5BY.
Tel: 01642 813785
Suppliers of presses and rollers.

Senefelder Press Original Lithography
6 Hyde Lane, Upper Beeding,
West Sussex, BM44 3WJ.
(contact Andrew Purches).
Tel/Fax: 01903 814331.
*Suppliers of lithographic materials, scraper
bars etc.*

Whatman International Ltd
Springfield Mill, Maidstone,
Kent, ME14 2LE.
Tel 01622 624125 Fax: 01622 670755
Paper suppliers.

**Yorkshire Printmakers and
Distributors**
26–28 Westfield Lane, Emily Moor,
nr Huddersfield, HD8 9TD.
Tel: 01924 840514 Fax: 01924 848982
*Suppliers of all printmaking materials,
tools, rollers, and own lithography inks.*

USA

Daniel Smith Inc.
4130 1st Street South
Seattle, Washington 98134
Tel: +206-223-9599 Fax: +206-224-0404
Email: sales@danielsmith.com
*Suppliers of printmaking materials
and own range of inks.*

The Graphic Chemical & Ink Company
P.O. Box 278, Villa Park
Illinois, 60181.
Tel: +708-832-6004
Email: GraphChem@aol.com
*Suppliers of a wide range of printmaking
materials and own range of lithography
inks.*

The Griffin Company, Inc.
1745 International Boulevard, Oakland,
California 94606-4596
Tel: +510-533-0600 Fax: +510-533-0601
Email: contact@griffincompanyinc.com
*Makers and suppliers of etching and
lithography presses.*

Rembrandt Graphic Arts
P.O. Box 130, Rosemount,
New Jersey 08556
Tel: +609-397-0068 Fax: +609-397-0666
Email: sales@rembrandtgraphicarts.com
*Suppliers of general printmaking materials
and stones.*

Stones Crayons,
1525 Overhulse Road NW,
Olympia WA, 98502
Tel: +360-866-2605
Email: scrayons@mindless.com
Suppliers of crayons and tusches.

Takach Press Corporation,
2815 Broadway SE, Albuquerque,
New Mexico 87102.
Tel: +505-242-7674 Fax: +505-888-6988
Email: Info@takachpress.com
*Makers and suppliers of lithography
presses, etching presses, ball-grained
lithography plates and rollers.*

EUROPE

Charbonnel
13 Quai de Montebello,
Paris, France.
Email: info@savoir-faire.com
*Suppliers of a wide range of printmaking
materials and lithography inks including
Noir a Monter and Noir a Velours.*

Polymetaal
Evertsenstraat 69 C, Leiden, 2315 SK,
The Netherlands & P.O. Box 694 Leiden,
2300 AR (mail order).
Tel: +3171-522-2681
Email: info@polymetaal.nl
*Suppliers of lithography presses and a wide
range of stones and printmaking materials.*

Steindruckerei Ernst Hanke
Brandstrasse 204
CH 3852 Ringgenberg
Email: steindruckehanke@bluewin.ch

Crocodile Moon Dance, Caroline Thorington, USA. 15.2 x 21.2in. (380 x 530mm), 1995. A ten-run lithograph printed from stone and from plate. The key image was drawn on stone and from this, two 'gum reversals' were made and used to print rainbow rolls. Further runs were drawn with crayon and tusche and by making deletions on the key image.

BIBLIOGRAPHY AND SUGGESTED READING

Adams, Clinton, *American Lithographer 1900–1960: The Artists and their Printers*, The University of New Mexico Press, 1983.

Adams, Clinton, *Nineteenth Century Lithography in Europe*, The University of New Mexico Press, 1998.

Adams, Clinton, Crayonstone: *The Life and work of Bolton Brown with a Catalogue of his Lithographs*, The University of New Mexico Press, 1993.

Adams, Clinton and Antreasian, Garo, *The Tamarind Book of Lithography: Art & Techniques*, Harry N. Abrams, 1970.

Arnold, Grant, *Creative Lithography and How To Do It*, Dover Books, New York, 1964.

Devon, Marjorie, *Tamarind: Forty Years*, The University of New Mexico Press, 2000.

Jones, Stanley, *Lithography for Artists*, Oxford University Press, 1967.

Knigin, Michael and Zimiles, Murray, *The Technique of Fine Art Lithography*, Van Nostrand Reinhold Company, New York, 1970.

Mary and Leigh Block Gallery, *Printmaking in America: Collaborative Prints and Presses 1960–1990*, Harry N. Abrams, 1995.

Porzio, Domenico, *Lithography: 200 years of Art, History and Technique*, The Wellfleet Press, 1982.

Printmaking Today, *Contemporary Graphic Art Magazine and authorized journal of the Royal Society of Painter-Printmakers (RE)*, Cello Press Ltd, London.

Senefelder, Alois, *A Complete Course of Lithography*, Da Capo Press, 1977.

The Tamarind Institute, *The Tamarind Technical Papers Volumes 1–17*, Tamarind Institute, 1974–1998.

Twyman, Michael, *Lithography 1800–1850*, Oxford University Press, 1970.

Vicary, Richard, *The Thames and Hudson Manual of Lithograph*, Thames and Hudson, London 1977.

INDEX

Black and White Landscape, Anne Meredith Barry, Canada. 16.4 x 22.4in.
(410 x 560mm), 1992.
Black-and-white lithography drawn using crayon and tusche and printed to show
the full extent and shape of the stone. Hand coloured with watercolour pencils.
Printed by Barry and George Maslov, St Michael's Print Workshop, Newfoundland.